Angels

Angels

Guardians of the Light

Karen M. Haughey

Hay House, Inc.
Carlsbad, CA

Published and distributed in the United States by:

Hay House, Inc., Carlsbad, CA
(800) 654-5126

Edited by: Jill Kramer
Designed by: Christy Allison

Library of Congress Cataloging-in-Publication Data

Haughey, Karen.
 Angels : guardians of the light / Karen Haughey.
 p. cm.
 ISBN 1-56170-316-8
 1. Haughey, Karen--Catalogs. 2. Angels in art--Catalogs.
 I. Title.
 ND237.H348 1995
 759.13--dc20 95-9104
 CIP

ISBN 1-56170-316-8

99 98 97 96 95 6 5 4 3 2
First Printing, September 1995
Second Printing, November 1995

Printed in Singapore through Palace Press International

Angel Paintings

Raphael

Gabriel

Transition

Falling of the Sun, Rising
 of the Moon

Body, Mind, Spirit

Spirit of the Valley

Elemental Trilogy

Angel of Louise

Essence of Louise

Windows of the Soul

Pisces

Illumined Aquarium

Astral Journey

Saint Michael

Anatomy of the Waves

The Four Elements

Apocalypse

Lily

Flight of the Phoenix

Crystal Mountain

Angel of Marilyn

Constellation

Celestial Nebula

The Discovery

Memories

Moonstone

Diaphanous

Communion

Gaia, or Angel of the Earth

White Horse

Mermaids

Ascension of Saint Michael

Butterfly

Fascination of the Fairy Children/
 Nocturne, the Association of
 Man and Spirit/Mother and
 Child Mermaids

The Angel of Prophesy

Angel for Ann Eastland
 (Healing Angel)

Mist

Angel de las Flores

Winged Friends I

Moon Fairy

Three Muses of Fate

Judith Engles, Goddess

Gloria Wilcox, Goddess

Two Angels for Karen

Angel of Hope/Angel of Faith

Mosaic

Zannah's Angel

In My Longing

Studio Angel I/ Studio Angel II

Foreword

I am so pleased to be publishing my friend Karen Haughey's exquisite angel book. Not only is she a brilliant artist, but she is a beautiful, metaphysical human being as well.

We both share a love of angels and all that they represent. I have several of Karen's works in my own home: *Angel of Louise, Essence of Louise,* and *Four Elements.* Every time I gaze upon them, I know I am in the company of loving, spiritual beings. I once gave a gallery showing of Karen's art in my home. My living room was covered with her glorious paintings. I so wished that I could have bought them all and just left them there on the walls forever.

I have watched Karen's art grow in the few years I have known her. Each new painting seems to have a deeper sense of spirituality to it. I can sense that the angels are directing every stroke. There are many of us who are very aware of the angelic beings around us. I know that I have several angels around me, loving and guiding me. Sometimes I feel their presence quite strongly.

I hope that you will make this book a part of your life, as it has special gifts to offer you. When you're in need of answers or just want to feel inspired by the sheer beauty and creativity inherent in Karen's artistry, open this book and let its light and love wash over you and become a part of your consciousness.

Remember that you are never alone. Angels are on this magnificent planet to attend to you, assist you, and love you. Love them back for being the glorious beings that they are. Be open to them, and you might even see your own angel one day.

With love,
Louise L. Hay
Southern California, 1995

Acknowledgments

I dedicate this book to my dearest friend, Louise L. Hay. Without her love and support, this book would never have been acknowledged or published. If we could practice and live to the fullest what she suggests in the books she writes, our lives would be so full, so light and executed with unconditional love for one another, today, tomorrow, and always.

Also, to Tom Barabas, whose music inspired my soul to paint the pictures that are held within this book, past and present.

To my family, who may not have understood my process contained within this book—my soul being turned inside out—wondering myself, at times, if I could withstand the transition of the same.

With love and gratitude, I wish to thank the entire staff of Hay House for all their efforts in the process of this book and its publication. A very special thank you to Reid Tracy for opening the door to this special project; to Jill Kramer, the most gentle and kind editor anyone could ask for, who indeed must be an angel herself; to Christy Allison, the artistic angel who designed and wove this book together; and to Ron Tillinghast, who is a grandmaster of combining the formality of business with the funniest wit of anyone I have ever had the pleasure of knowing. And many thanks to the people at The Imagery Group for doing a wonderful job photographing my work.

And my many, and dear friends, too many to mention but still endeared, who held my hand and dried my tears through the birth, beginning to end. I love you all so much!

Thank you from the bottom of my heart.

*A special thank you to my daughter, Michelle, who was always there with hugs and a smile (even when I didn't feel like giving one)!

Introduction

To introduce this book properly, I must go back to the year 1984, when my art, as I know it today, began.

I have always been artistic, having been a commercial artist and designer most of my life. My work, up until the date above, was usual and ordinary, anything but spiritual, as I was a fashion illustrator and visual presentation designer for department stores and free-lance accounts. The only angels I ever saw were those used for ornamentation at Christmas. *Spirituality* was only a word to me, something I had mixed feelings about, and surely nothing I practiced on a daily basis, until one day that I will never forget, when my life and art changed forever.

It was a typical morning. I was ready to go to work on an account in the San Francisco Bay area. I was driving along a beautiful coastal route called Interstate 280, when out of nowhere this intense, overwhelming vision came to me of angels!

There were two of them, one hovering above the other. One was looking ahead, hand held over the sibling's head, the other looking back. I saw them in color and composition and *knew* there was a clear message and a painting that *had* to be created as soon as possible. It also had to be painted large, something I was not accustomed to, since all my graphic formats were never bigger than 11 x 14 inches in diameter. What I was seeing was 30 x 40 inches.

This unfamiliar conceptual vision was anything but commonplace for me, and I really felt the urgency with which it was supposed to be painted. And so it was, within a week's time, this angelic apparition came to life, unlike anything I had ever painted in my life as an artist.

When this piece of art was painted, angels were not a common household word as they are today, so when it was completed, I really didn't know what my next step was other than just trying to figure out what I had done.

One week passed after the first vision was brought forth. Then came a message just as strong as the vision:

"In space and time have I traveled,
through perilous journey charting a course
I know not.

"In direct concentration, my energy now
thrust forth to complete my conquest to
which it sought idealistic mannerism.

"Come forth now and look upon your
inner desires and self-descriptions as they
were first delivered unto you, starving
inward attributions.

"Now take of thyself unto the multitudes
and present latent abundance, embracing
it near. Collective endurance is as ebb,
fortitude in virtuous aptitude, to this you
must adhere and come forthright."

When I finished typing it out, I sat in amazement, staring at a
script that was totally foreign to me in context. It came through me
like something I was well versed in, yet I didn't have a clue as to
what I was writing about, much like the vision I saw of the angels.
I remember sitting quietly one night by myself with a dictionary,
trying to analyze what I had written.

Just three years ago, I really came to understand what I had writ-
ten and what it meant to me. It was actually a prophetic message
regarding my art work, and where it was headed. Yet another week
passed and another message was given:

"Lay waste the kings of time to hear the
trumpets that sound of the east.

"Hear greatly the numbers called unto you
that you may know of the great noise.

"Land shall follow land, fear and confu-
sion to the memory shall follow.

"What do you know of your future, that
you may contribute to my sentence and
of my bleeding?

"There must you uproot the rose from its
thorn, to cast away the earth that it
was born.

"Your hearts now are of playgrounds to the
evil that lives within. Hear not the voices,
but listen to the lark of days gone past
the gate."

Since these three dramatic transmissions have come and gone, five hundred visions have passed through my hands onto canvas. I'm not sure why I was chosen to bring these forward. But I do know that my life has been enriched with blessings to help others onto a path that can be experienced on a one-to-one basis, taking into account each person's own unique spirit and mortal life here, on our one and only planet Earth.

When I wrote this book, the obstacles that I was going through at the time made me anxious about my own future. I do know that what I've learned from my past has caused me not to look back over my shoulder, but to keep striving ahead and to never, never give up! I think it would be fitting at this time to tell any aspiring artists reading this book that they, too, must *never* give up on their dreams.

In this profession, you never stop auditioning. You have to put your heart, soul, and energy into each day. I talk to a lot of artists who tell me that they just want to give up due to rejection and compromise. I tell them that these roadblocks are things that must be overcome in order to progress. Follow your heart, and *you will succeed*! I send you blessings on your journey.

Remember no man (or woman) is an island—life was meant to be shared together and unconditionally with *LOVE!*

RAPHAEL

The archangel Raphael came to me in a vision that was originally a special project for a church in California. As he came through me, I felt the energy to be compassionate and concerned, as you can see by the expression and longing in his face. When the painting was completed, I noticed that there was a body enfolded within his robes, as if he were cradling a child. Study the picture (looking particularly at the lower center area of the painting), and you will see what I'm referring to.

In Hebrew, Raphael means *the healer of God*, which I believe to mean our emotional and physical healing of mankind, on all personal levels of understanding.

30 x 40 Sincerely Yours Gallery, Del Mar, CA

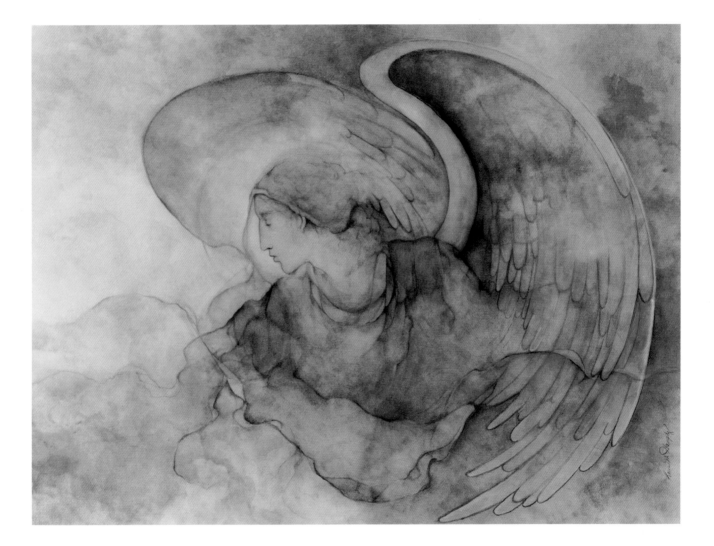

GABRIEL

After I painted *Raphael*, I felt the urge to paint Gabriel, not knowing that they were in sequence to each other within archangel hierarchy. As Gabriel came through me, his posture changed several times on my illustration board (this is typical when I paint).

The final position turned out to be a hand outstretched with head facing downward, as if there was a blessing and/or healing that was being delivered.

In Hebrew, Gabriel means *the strength of God*, overcoming one's fears. At the time he was painted, I was immersed in facing my own fears, and knew that I had to challenge them.

After completion of the painting, many of my co-workers and friends told me that they could actually "feel" an energy or presence around the art itself. I find it interesting how I, the artist, can bring forth these visions, yet I am not able to experience any vibration or emotion on a personal level—it's as though it comes through me, and that's that!

One of my dear friends, Rita Marie Driscoll, who at the time was having health challenges, went into the gallery where Gabriel was being shown. She put her hand up to the glass on the painting, and she told me that she felt a vibration and was able to put pressure on her body where there was ultimate pain before. We both cried. We were thankful. She had been healed by God, and not because of my painting.

30 x 40 Angel Gallery, Portland, Oregon

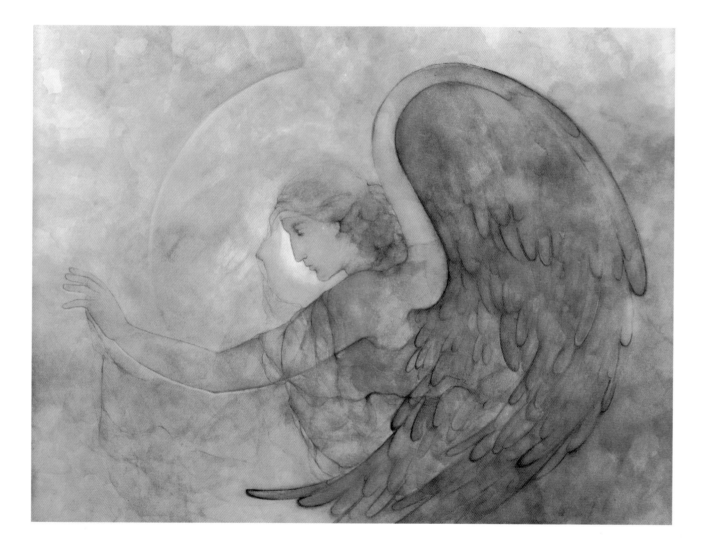

TRANSITION

I PAINTED *TRANSITION* AT A TURNING
POINT IN MY OWN LIFE. IT WAS BETWEEN
SUMMER AND FALL OF 1987, JUST
AROUND THE TRANSITION MARKING MY
FATHER'S DEATH.

IF YOU NOTICE THE LEAF TO THE LEFT-
HAND SIDE OF THE PHOTOGRAPH, THAT IS
A REAL LEAF, PLUCKED OFF OF A FICHUS
TREE DURING THESE SAME TRANSITIONAL
MONTHS OF THAT YEAR. WHENEVER I
LOOK AT THAT PAINTING, WHICH HAS
BECOME ONE OF MY MOST POPULAR
PIECES, I THINK OF MY FATHER AND HOW
MUCH I MISS HIM AND HIS UNCONDITION-
AL LOVE FOR ME.

THIS WAS ALSO AN EXPLOSIVE TIME IN MY
ART CAREER, AN INTERIM OR FORMATIVE
TIME OF MY CAREER—THE SPIRITUAL
ONSET.

20 X 30 PRIVATE COLLECTION

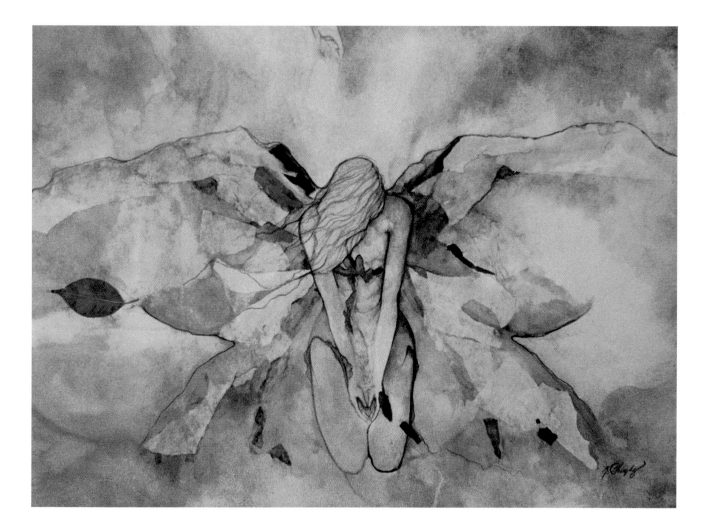

FALLING OF THE SUN, RISING OF THE MOON

WHEN I PAINTED THIS WORK, MY
THOUGHTS WERE FOCUSED ON THE
SPIRITUAL ASPECT OF DAY TURNING
INTO NIGHT, OR VICE VERSA—ANGELS
USHERING IN THE SUN, THE MORNING
LIGHT, AND THEREFORE BRINGING IN
THE NIGHT AS WELL. IT'S A CYCLE, ONE
BALANCING THE OTHER IN PERFECT AND
DIVINE ORDER WITHOUT THE INTER-
VENTION OF HUMAN BEINGS TO DIC-
TATE OR CONTROL ITS PROCESS. WE, AS
HUMANS, ARE REALLY NOT IN CONTROL
OF ANYTHING OR ANYONE EXCEPT
OURSELVES.

30 x 40 PRIVATE COLLECTION

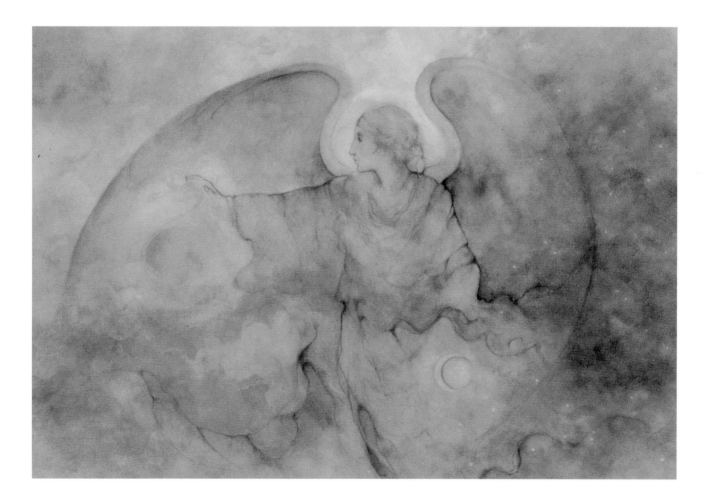

BODY, MIND, SPIRIT

THIS PIECE OF ART WAS A SPECIAL COMMISSION. AT THAT TIME, MY CLIENT ASKED THAT I MERELY "TUNE IN," SO TO SPEAK. I FELT THAT THE NUMBER "3" WAS SIGNIFICANT TO HER SOMEHOW. SHE VALIDATED THAT "3'S" HAVE CONTINUALLY BEEN INHERENT TO HER LIFESTYLE, ON BOTH A SPIRITUAL AND PHYSICAL BASIS. AT THAT POINT, I VERY CLEARLY SAW AND FELT BODY, MIND, AND SPIRIT AND HOW IT INTEGRATED INTO HER LIFE'S PATTERN.

30 X 40 PRIVATE COLLECTION

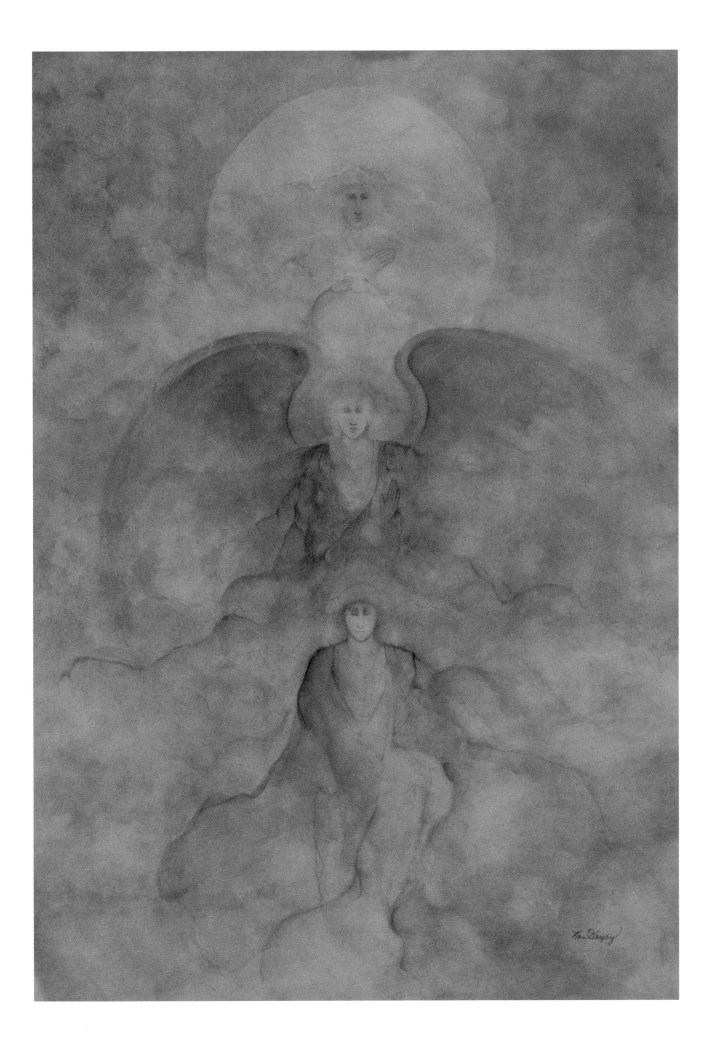

SPIRIT OF THE VALLEY

This was a special commission for a corporate account involving three San Francisco Bay area shopping malls. It was requested that I create some type of memorial lithograph to commemorate an event called "East Bay Living," depicting the lifestyle of Northern California. The area where we originated the concept was landscaped in oak trees, rolling hills, poppies, and a beautiful blue sky.

My own interpretation was the spirit itself captured within the trees and the surrounding elements.

20 x 30 Private Collection

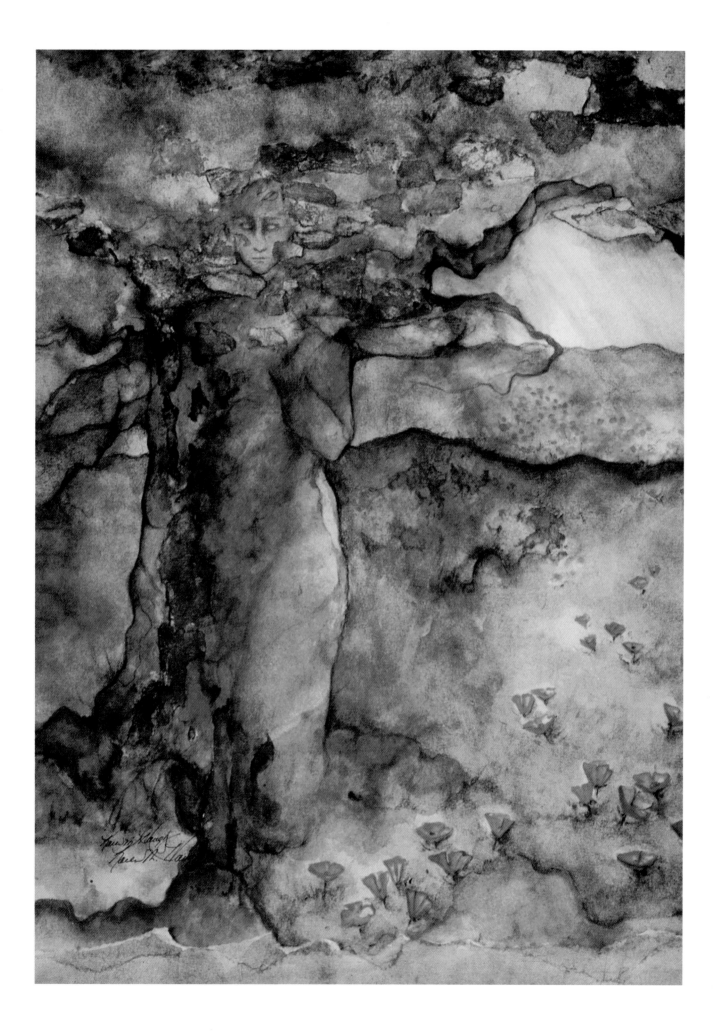

ELEMENTAL TRILOGY

THIS IS ONE OF MY FAVORITE PAINTINGS; IT SIMPLY SUGGESTS THE INFINITE CIRCLE OR GLOBAL KNOWLEDGE OF THE ELEMENTS, EARTH AND WATER, RELATING TO ONE ANOTHER AS A UNIT. THE ANGEL, OF COURSE, REPRESENTS AIR, OR THE HEAVENS. THE RECLINING LADY REPRESENTS EARTH, AND THE MERMAID, WATER.

30 X 30 PRIVATE COLLECTION

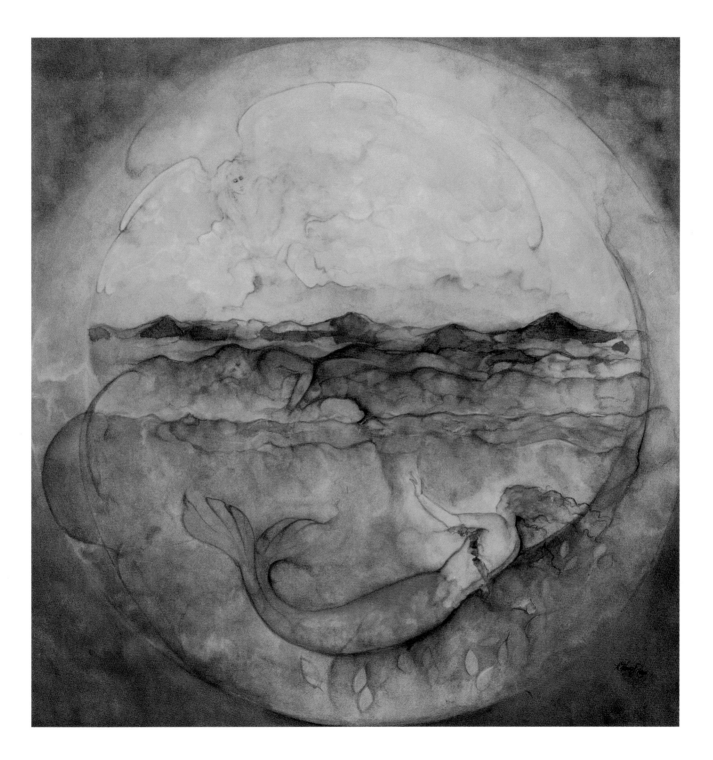

ANGEL OF LOUISE

Angel of Louise is a devoted concept of the angel that belongs to my dearest friend, Louise Hay. The laurel that the angel carries represents the highest level of accomplishment and spiritual conquest, with respect to knowing love within the world, and giving it back with abundance.

30 x 40 Private Collection

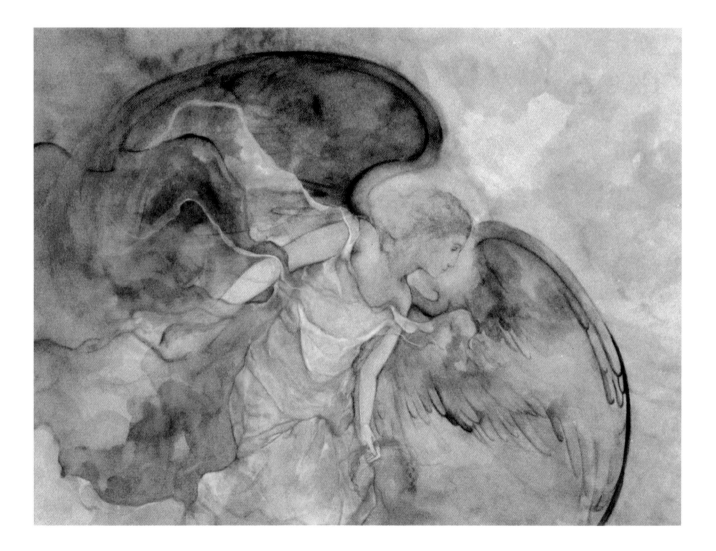

ESSENCE OF LOUISE

WITHIN THE PAINTING, I WANTED TO CAPTURE—THROUGH INSPIRED GUIDANCE—THE SOUL ESSENCE OF LOUISE'S SPIRIT. THE SPIRIT CAME THROUGH ME AS SOFT, GENTLE, AND COMPASSIONATE, ALONG WITH ANCIENT KNOWLEDGE AND DEEP WISDOM. I ASSUME THAT THE SYMBOLS ETCHED WITHIN THE PALMS OF HER HANDS ARE RELATED TO SACRED GEOMETRY.

MY OWN UNDERSTANDING AND BELIEF—SINCE YOU MUST UNDERSTAND AS THE READER THAT I AM MERELY JUST A CHANNEL FOR THESE VISIONS, AND I RARELY CAN TRANSLATE WHAT IS COMING THROUGH—IS THAT THE VISION IS DIRECTLY RELATED TO THE PERSON WHO IT IS INTENDED FOR, ON A DEEP PERSONAL LEVEL. THUS, THE CIRCLE WOULD MEAN INFINITE, NEVER-ENDING, UNIVERSAL KNOWLEDGE. THE TRIANGLE REPRESENTS BODY, MIND, AND SPIRIT; AND A TEMPLE TO THE HIGHER SELF IS AN ACKNOWLEDGMENT TO GOD. THE ROBES AND HEADPIECE IMPART A VERY STRONG FEELING OF A PRIESTESS OR GODDESS.

30 X 40 PRIVATE COLLECTION

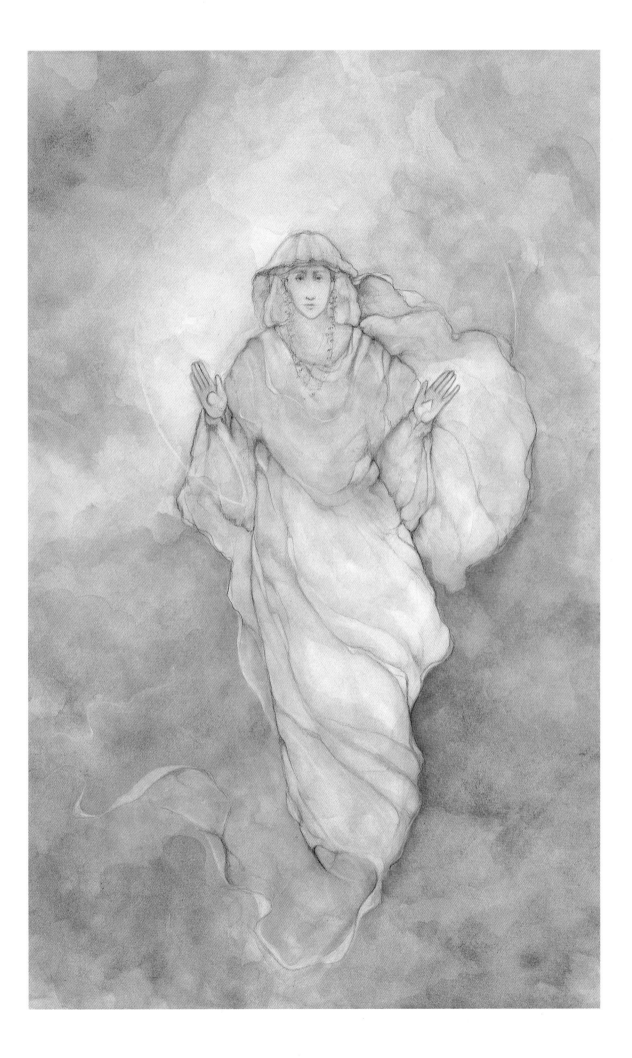

WINDOWS
OF THE SOUL

I WAS ON A TRAIN HEADED TOWARD SOUTHERN CALIFORNIA WHEN THIS VISION CAME TO ME. I RECALL READING A BOOK IN TRANSIT, AND THE VISION I RECEIVED WAS SO STRONG THAT I STARTED SKETCHING IT ON ONE OF THE BOOK'S PAGES.

THE MEANING OF THE VISION IS STILL A MYSTERY TO ME. HOWEVER, AS I STATED BEFORE, THIS IS NOT UNCOMMON WHEN I PAINT.

16 X 24 PRIVATE COLLECTION

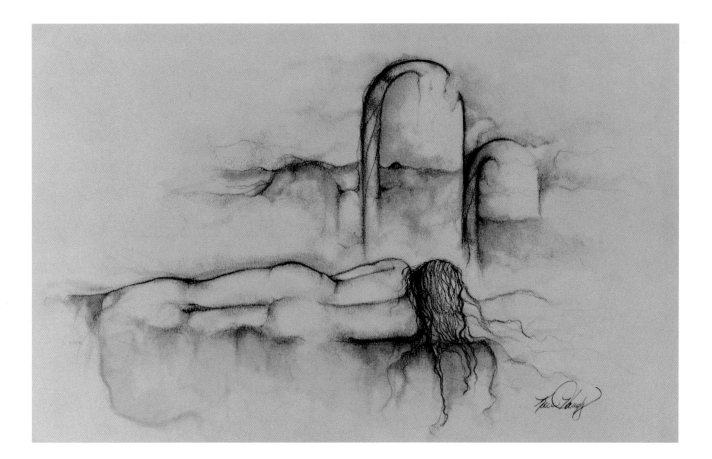

PISCES

Pisces was a strong vision—two mermaids swimming in synch with one another. There was tremendous energy behind this vision, and there was a force, or "tug," that was associated with completing this painting.

Shortly after the painting was produced and put on the market, a gentleman, whose love interest was a recently deceased Pisces, purchased it. This man shared the sentiment that the painting was an omen from the one he loved.

18 x 40 Private Collection

ILLUMINED AQUARIUM

This painting was born from my own love of the sea and my fascination with mermaids and the folklore surrounding them.

I often wonder if they really *are* real; maybe they just keep themselves hidden from mortals—something like sea-angels. You know they're around, but you just can't see them with your physical eyes (most of the time, anyway).

If you see mermaids as I do, you will see with your heart and with your third eye. That's just as real, in a sense, as your physical reality—what you think you're seeing on the surface.

Believe in your imagination!

30 x 40 Private Collection

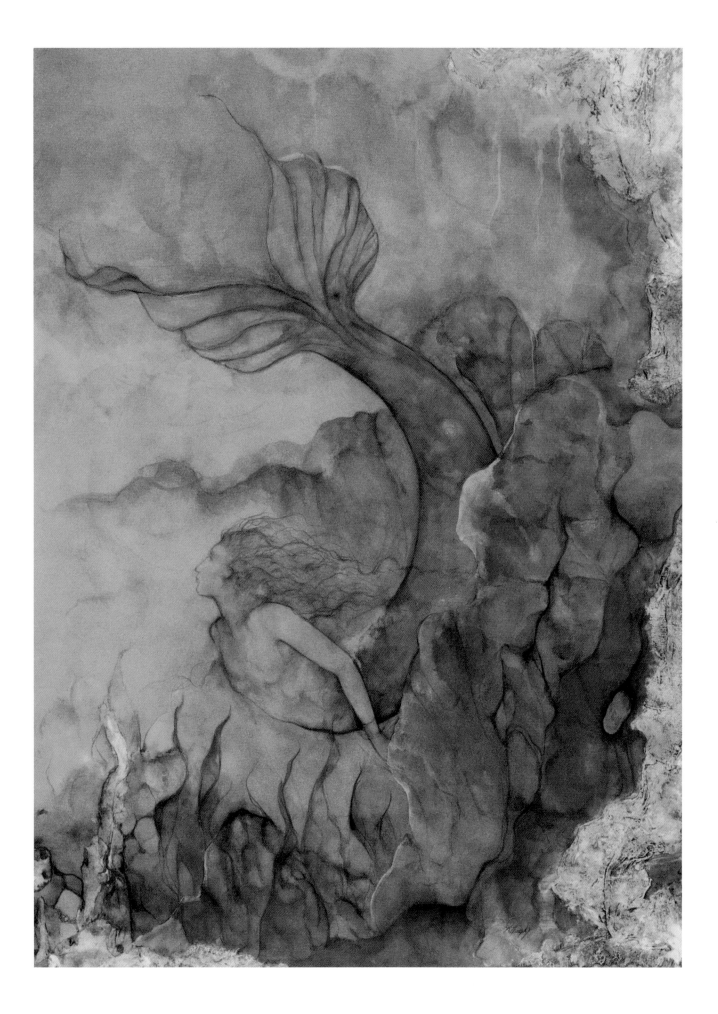

ASTRAL
JOURNEY

ASTRAL JOURNEY WAS PAINTED FOR A

COUPLE WITH A VERY SPIRITUAL

NATURE. THEIR ESSENCE CAME

THROUGH VERY CLEARLY, AS YOU CAN

SEE HERE.

30 X 40 PRIVATE COLLECTION

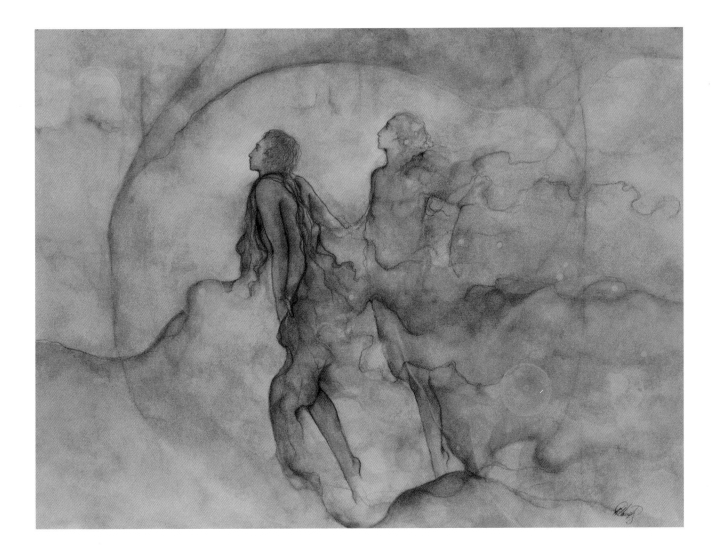

SAINT MICHAEL

One of my most powerful paintings, this came to me first as a commission, which changed several times before the actual image came through as seen.

I painted *Saint Michael* when I was going through some pretty heavy stuff in my life, on both an emotional and physical level. I found solace in the creativity of producing Michael overall. I realized that after I painted him, he brought me to great heights and potential within my career and my personal life.

20 x 30 Private Collection

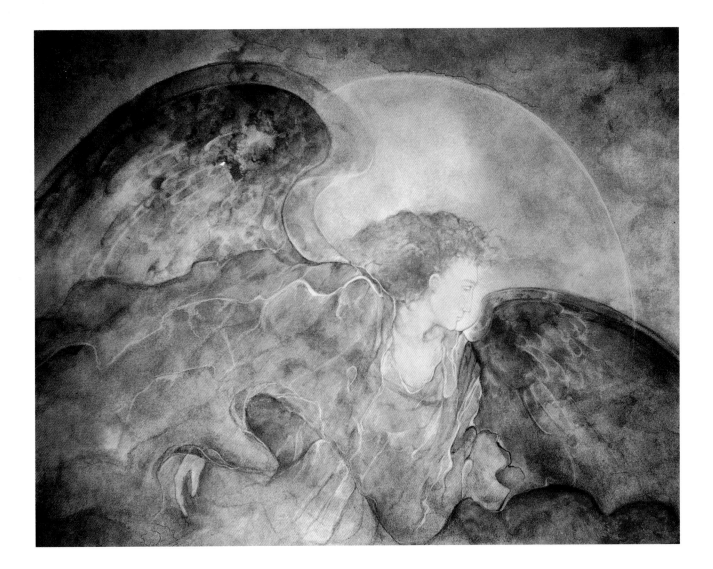

ANATOMY
OF THE WAVES

ANATOMY OF THE WAVES, AGAIN, WAS
A BLESSING FROM THE SEA, AS I FEEL
THAT WAVES THEMSELVES ARE SPIRITS OF
SOME SORT. THE OCEAN IS A GREAT
MYSTERY TO ME, WITH ALL ITS FORMS
AND SPECIES. I HAVE GREAT RESPECT
FOR THE OCEAN AND THE ENERGY THAT
EMANATES FROM IT.

18 X 24 PRIVATE COLLECTION

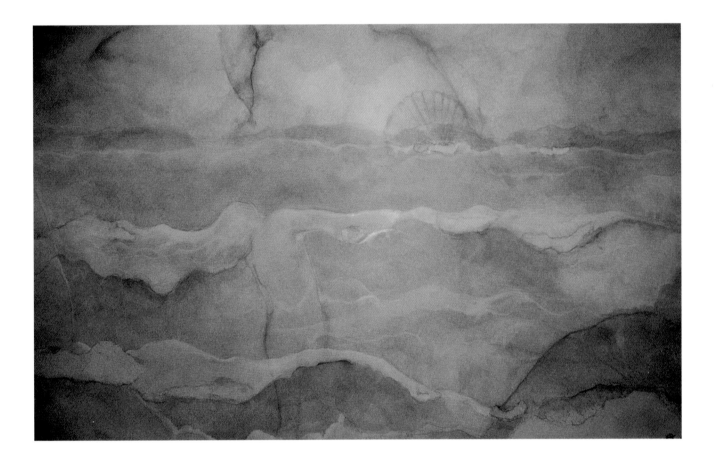

THE
FOUR ELEMENTS

This work was part of the series that included *The Seasons* and *The Elementals*. I could envision these heavenly beings in my mind as spirits or muses. The elements—wind, earth, water, rain, and fire—all depict definite personality complexities:

Wind is translucent, or like a cloud formation—powerful, yet gentle and intangible. You can always perceive its presence, but you cannot see it.

Earth, or Gaia, came through as fruition, all things that are born of the earth, our ever-present abundance.

Water and/or Rain is the cleanser and purifier, the hydrator, a blessed element that we, as mortals, cannot do without.

Fire is our ally; if not respected, it is our worst enemy.

I ponder over the elements, I think of their dual personalities, similar to that of the human race, with the positive and the negative characteristics that are inherent to it.

30 x 40 Private Collection

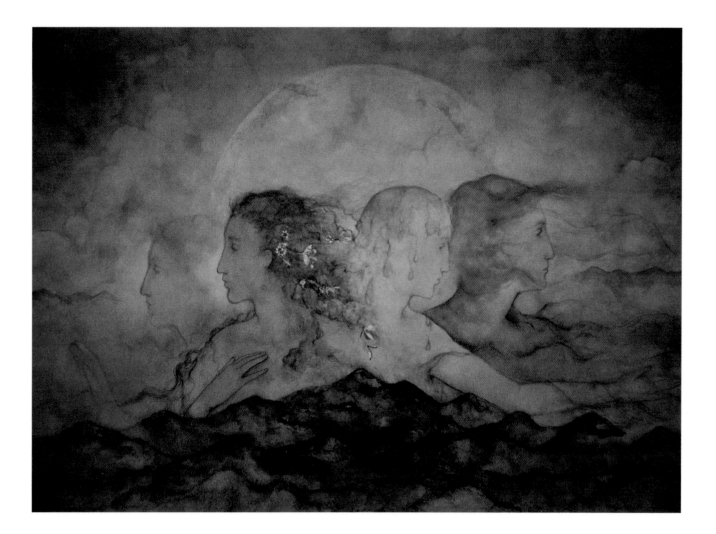

APOCALYPSE

Apocalypse came to me in a dramatic way, full of passion. The angel depicted within the painting embodies strength; I recall the long hours I put into this piece.

I had the feeling that I had to finish this work as soon as possible, although I didn't know why until the last minute. Two days before it was finished, the name *Apocalypse* came through, but at the time, I didn't even know what it meant. I looked it up in the dictionary and was astounded by its meaning.

Soon after completion, it was bought for a very powerful woman who made a major impact on me and my life. I wonder if the strength of the name and the person it went to had anything in common.

It seems as if every painting I do is a learning experience for me, as well as for the people for whom I paint them.

30 x 30 Private Collection

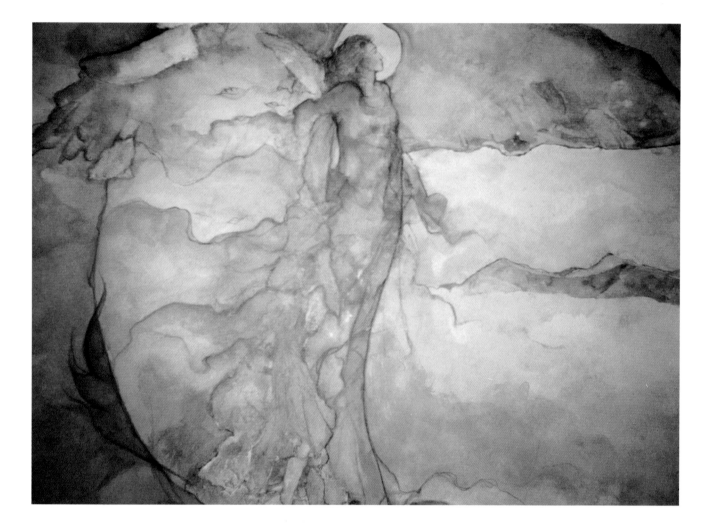

LILY

The Calla Lily is one of my favorite flowers, and whenever I've had the pleasure of being around them, I study and perceive them in both a creative and spiritual sense. Therefore, to me, the center of the lily, or the pistil stem, is a Deva, or the spiritual being of the flower itself.

20 x 30 Private Collection

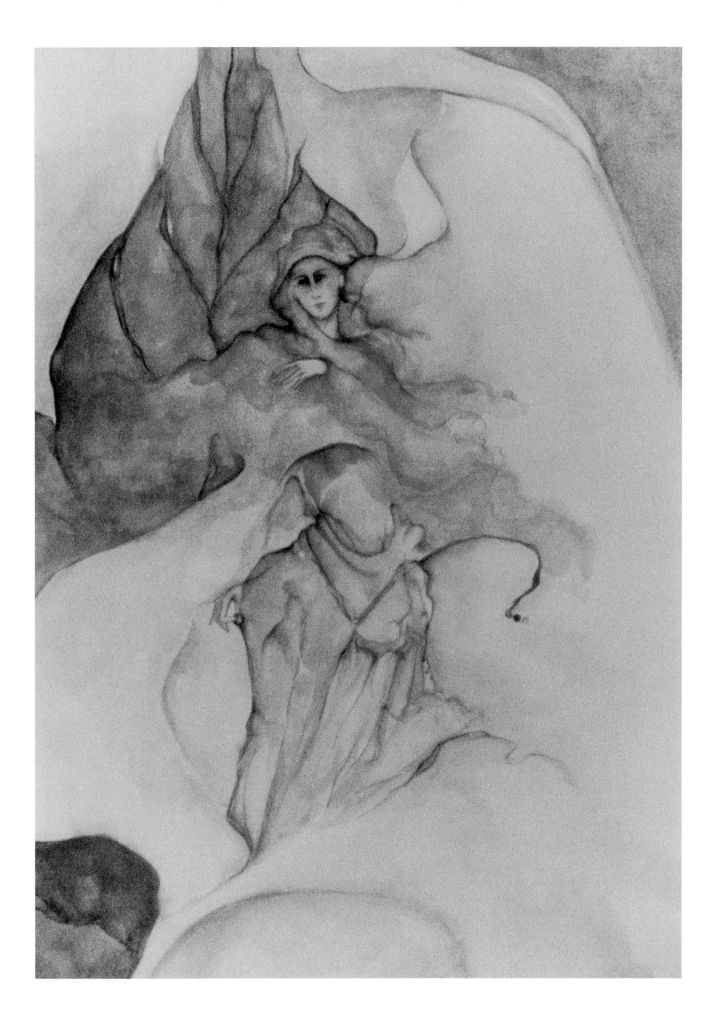

FLIGHT OF
THE PHOENIX

Flight of the Phoenix was origi-
nally contracted for a commer-
cial account, but, as usual, it took
some turns of its own. Given the
name of that mystical bird that
consumed itself in fire then came
back to life, this piece sold into a
private collection soon after
being produced.

11 x 14 Private Collection

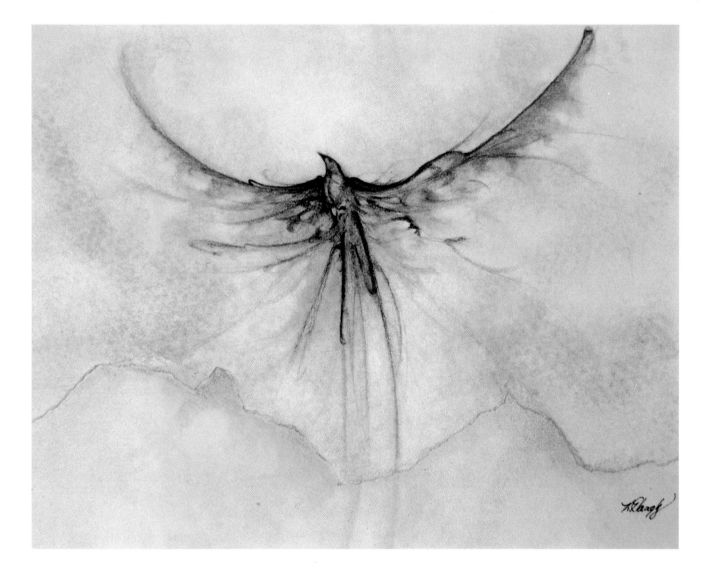

CRYSTAL
MOUNTAIN

In 1987, a dear friend and colleague presented me with a gift—the first crystal I ever owned. It stood about six inches high and weighed about three pounds. It was beautiful, and although I didn't know too much about the properties of crystals, I was fascinated by it and just loved staring at it.

Of course, a painting was the natural outgrowth of my new interest. What I envisioned was that the "lacy" growth within the crystal itself was a spirit. Some people say it looks like Moses descending the mountain with the Ten Commandments.

30 x 30 Private Collection

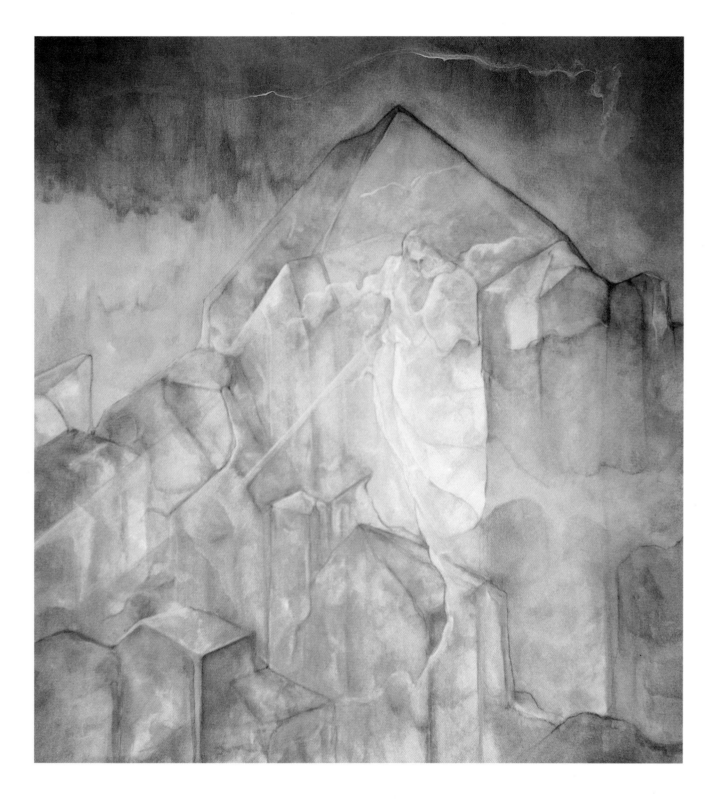

ANGEL OF MARILYN

After I started getting the reputation of being the "Angel Lady," more and more people began asking me to paint their specific, personal angel. So, this work was a commission for a special woman, Marilyn Leidecker, who was a hypnotherapist and teacher of same. She was a definite teacher for me, and a wonderful friend. So, her angel came to be. It has hung in her office for years and has since been seen in literature and magazines, including *Angel Times* out of Atlanta, Georgia.

18 x 24 Private Collection

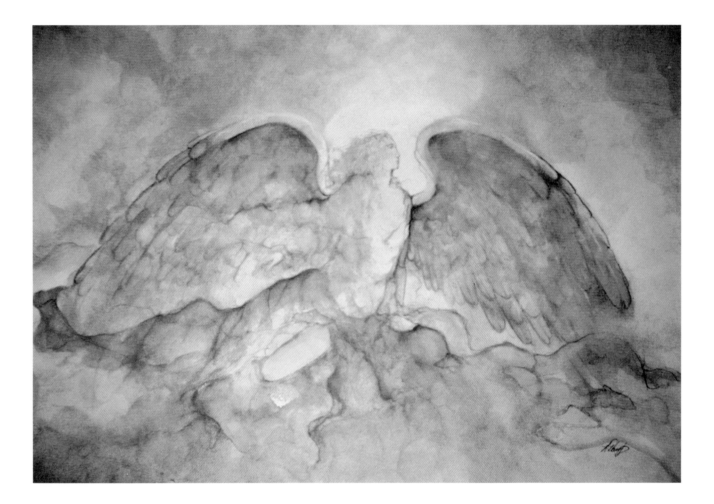

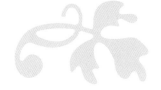

CONSTELLATION

THIS WAS MY FIRST ROMANTIC
APPROACH TO THE CELESTIAL—THE
MOON AND THE STARS. HAVE YOU EVER
LOOKED UP INTO A STARRY HEAVEN IN
THE STILL OF THE NIGHT AND SEEN
MORE THAN JUST THE OBVIOUS?

20 x 30 PRIVATE COLLECTION

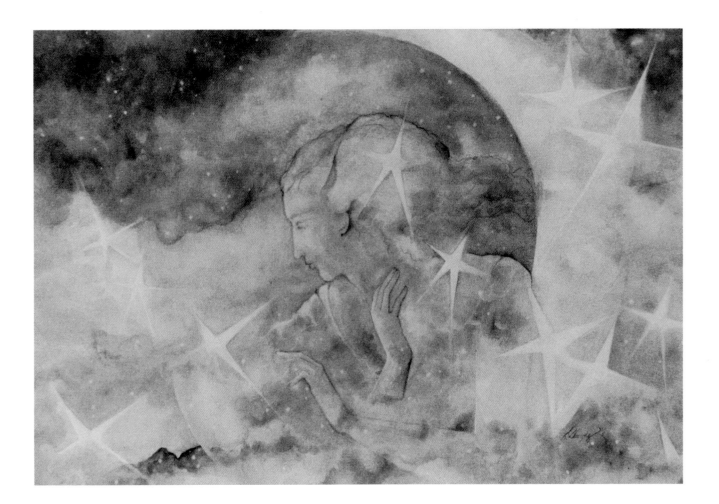

CELESTIAL NEBULA

Celestial Nebula was a rebirth of *Constellation*—again, my own fascination with the starry sky and the face of the pale moon and the ever-present spirit of same.

30 x 40 Private Collection

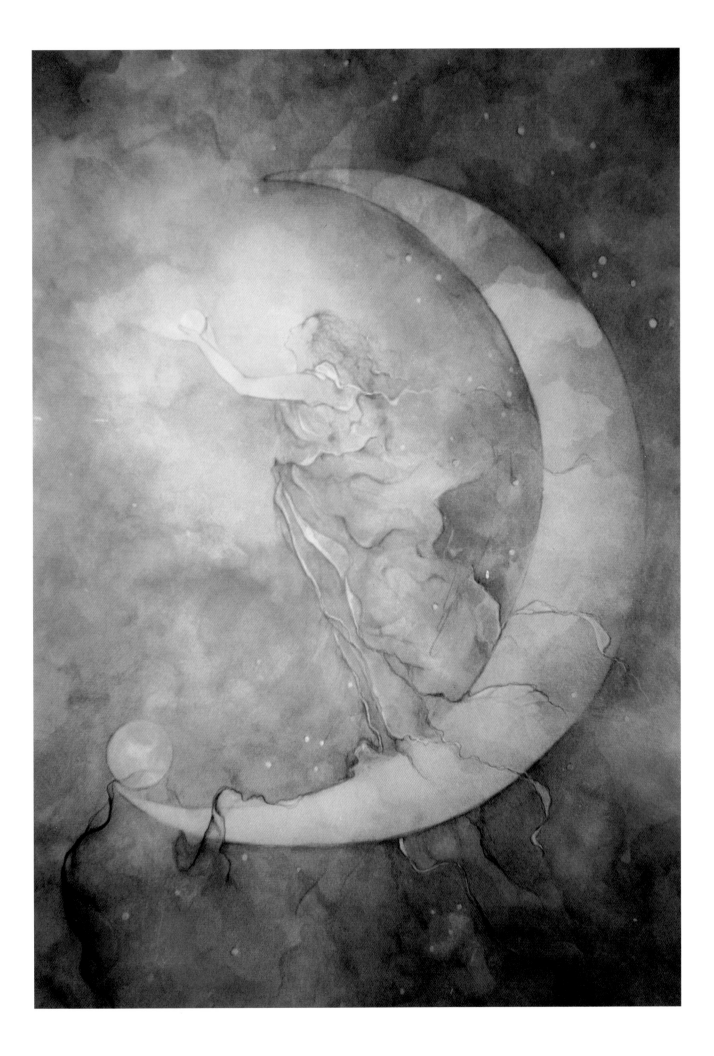

THE
DISCOVERY

The Discovery is, perhaps, one of my favorite paintings. As I mentioned before, I love the sea, and I especially love mermaids. When I paint them, I let my mind drift, wander, and play with the idea of what their life would actually be like—how they think, what they do...are they any different from mortals?

I captured this pair being fascinated and overwhelmed with something they have just encountered. This is where I hope you will allow your own imagination to flourish. What do you think they are looking at? What have they found? Do you see the faces in the rocks?

30 x 40 Private Collection

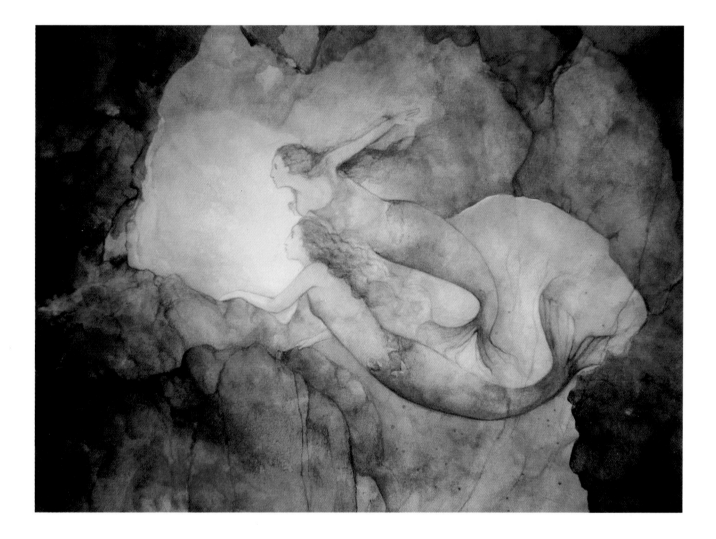

MEMORIES

Many years ago, I lived in a small town called Mission San Jose, which was originally inhabited by the Ohlone Indians in the 1700s and early 1800s. Mission San Jose is also noted for a mountain range called Mission Peak, which I gazed upon every day outside my home's balcony.

When I painted *Memories*, it was in direct reference to the Peak itself. As I continued working on the piece, the feathers started coming in for no reason that I had originally intended. I soon found out after the panting was put on the market that the Ohlone Indians had also inhabited the Peak, which I hadn't known at the time that I created the work.

I have often wondered if there was a revelation beyond my conscious mind, and how I brought these images together. I do know that some of my most powerful work came into being while I lived in that area.

11 x 24 Private Collection

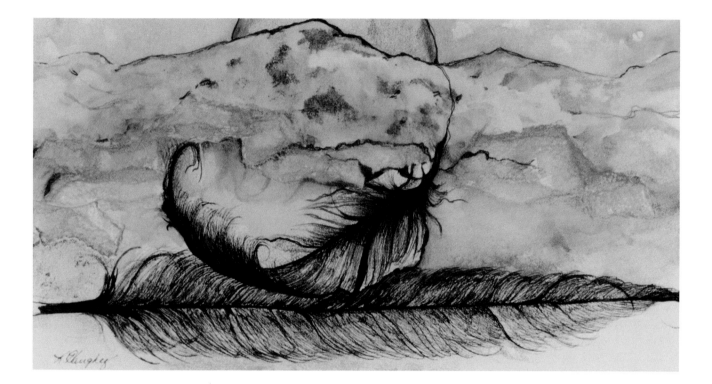

MOONSTONE

This was a commission from a woman who wanted me to paint her higher self or spirit guide. Almost immediately after I sat down with her, I felt a dominant, strong female Indian around her space, although I could see no *visible* indication of any Indian influence around her being. She was an attractive Caucasian woman with silver hair.

She validated my feeling and told me that she had felt an Indian presence or association around her for many years. I then proceeded with my own intuition, and Moonstone was created.

Moonstone was featured in the first edition of *Angel Times* magazine in November, 1994.

20 x 30 Private Collection

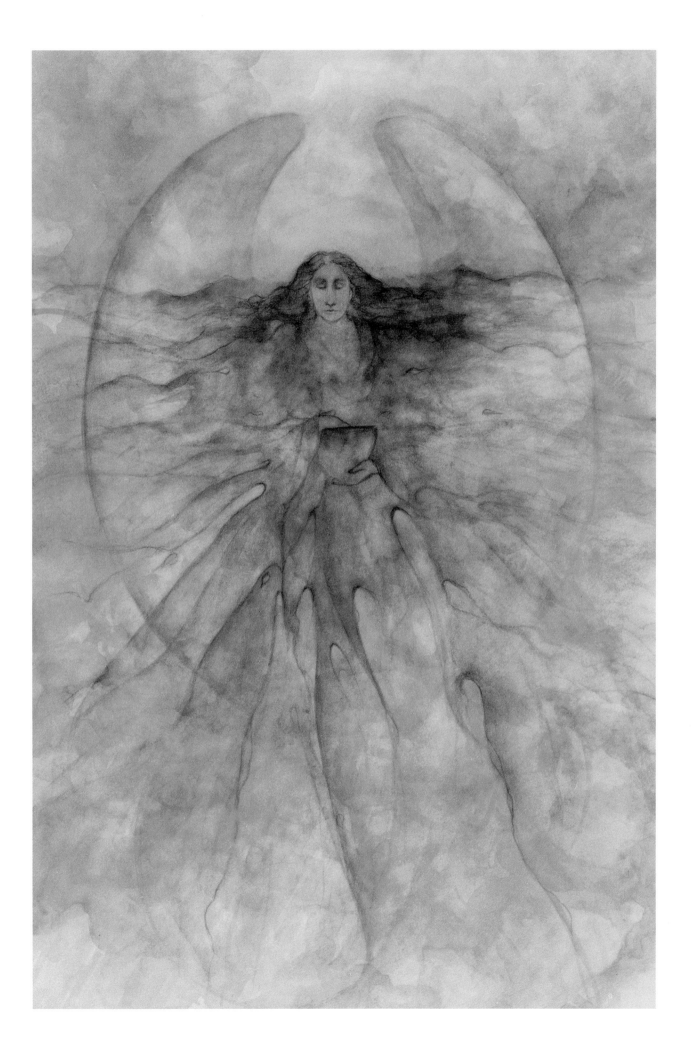

DIAPHANOUS

Diaphanous came through just before the painting, *Memories*. There is the same type of electrically charged energy, with a strong vision of a robed or gossamer being floating through a cavern of malachite.

12 x 30 Private Collection

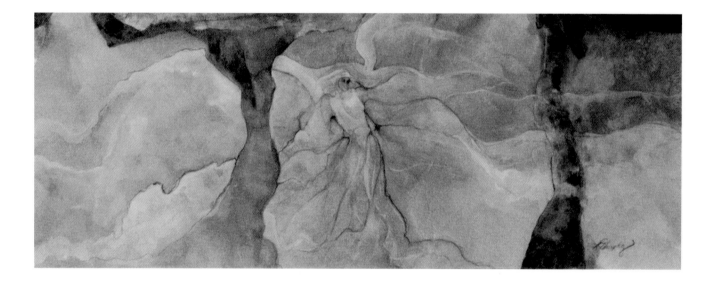

COMMUNION

Communion can only be observed as physical body and spirit merging, or a human being coming into a higher awareness of self or of God, both a union.

When I had my first vision back in 1984 of angels, I clearly felt that this was a spiritual communion. My life has not been the same in any way, shape, or form since that time. I am asked all the time how I get in touch with that part of me. Well, I can sincerely say that there are no clear-cut answers, other than being aware of my thoughts, actions, and how I choose to apply myself to my own being and to others around me.

Remember that whatever energy you put out to the universe will, in turn, come back to you, for better or worse.

30 x 40 Private Collection

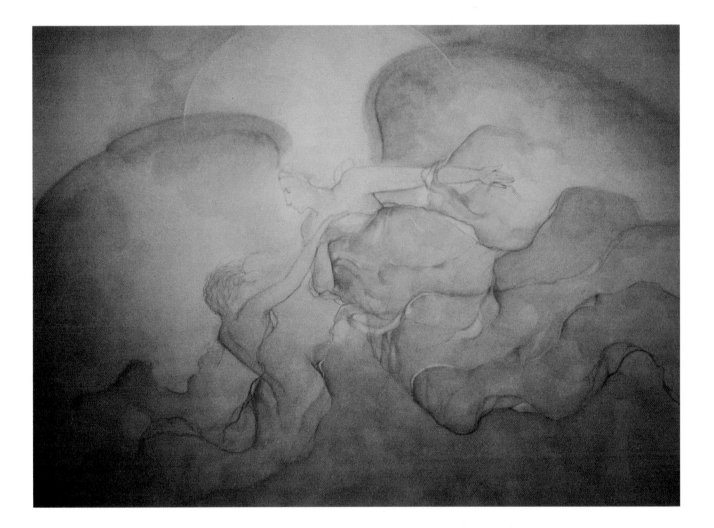

GAIA,
OR
ANGEL OF THE EARTH

Depicted from mythology, Gaia is
Mother Earth, the giver of life,
the Greek Earth Goddess and
Mother of the Titans.

20 x 30 Private Collection

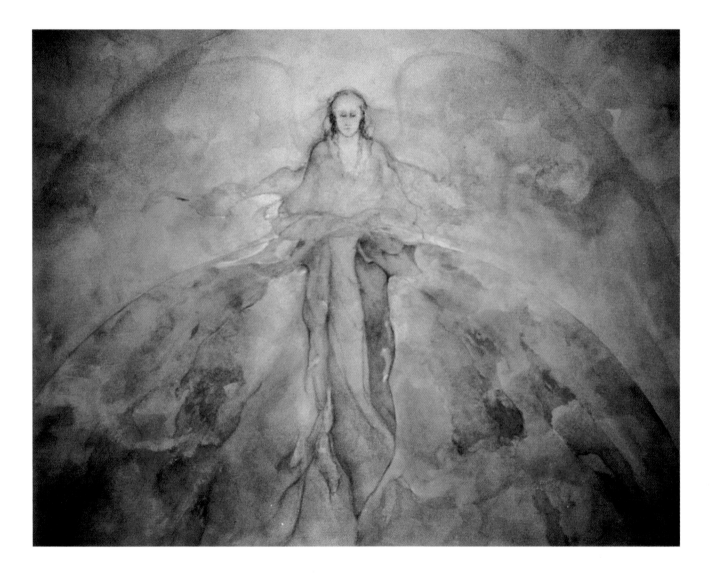

WHITE HORSE

This was a commission for a couple that had property in Sedona, Arizona. One evening we all went out for dinner in Northern California to discuss the particulars of what they wanted to see within the painting itself. At that moment, a strong vision started coming through me of an Indian face in the clouds over a red mountain butte, and from that came the mandala, a circle, and the feathers. I started sketching this piece for the couple right there on my paper place mat as they watched.

I was amazed when the two told me that the mountains I depicted in the sketch are the exact same mountains directly facing their property. I must add that I have never been to Sedona.

20 x 30 Private Collection

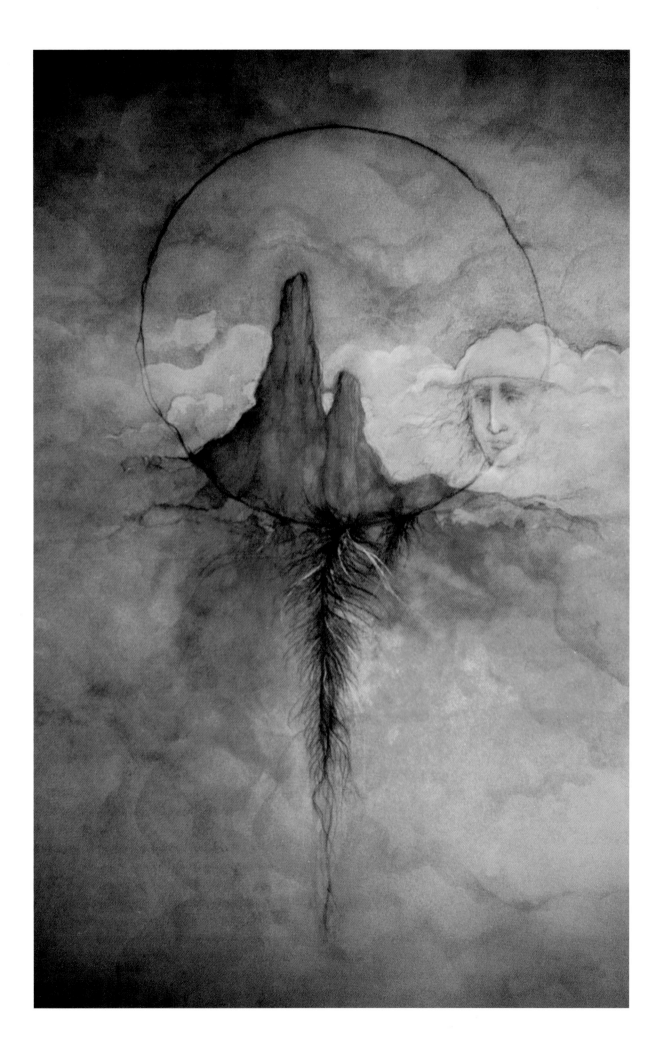

MERMAIDS

MERMAIDS WAS A SPECIAL COMMISSION FOR A CLIENT WHO LOVES MERMAIDS AS MUCH AS I DO. SHE GAVE ME COLOR AND DIMENSION, AND I LET MY CREATIVE INTELLECT TAKE CARE OF THE REST.

22 X 28 PRIVATE COLLECTION

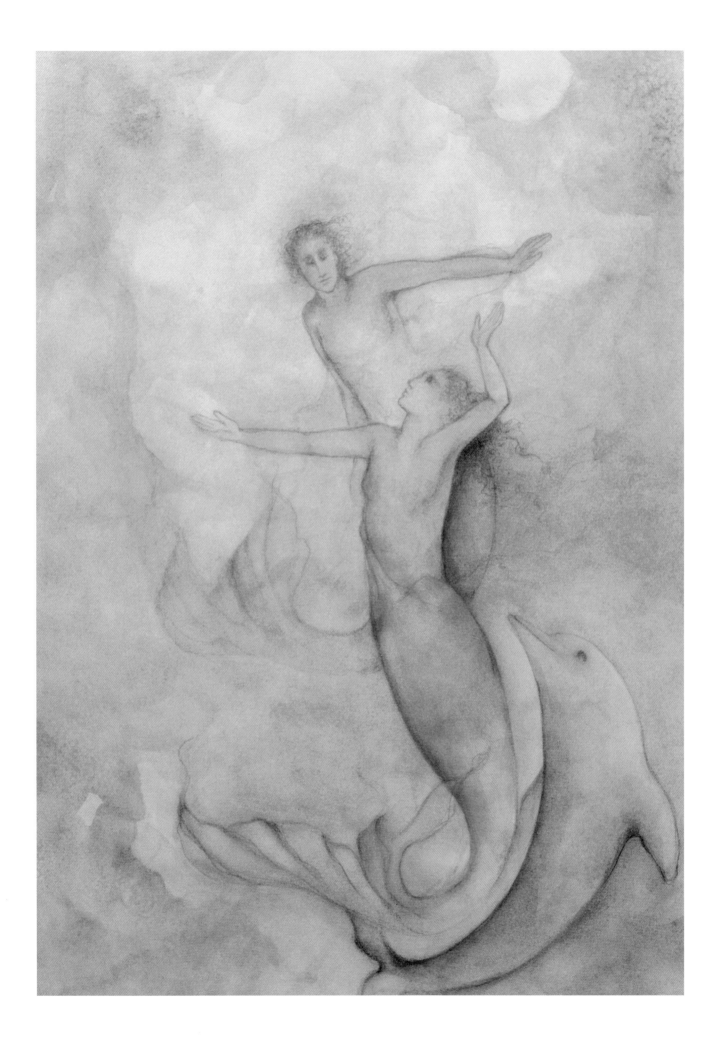

ASCENSION
OF
SAINT MICHAEL

Ascension of Saint Michael was a dedication to Unity Church in Fremont, California. The original is still housed there.

30 x 40 Private Collection

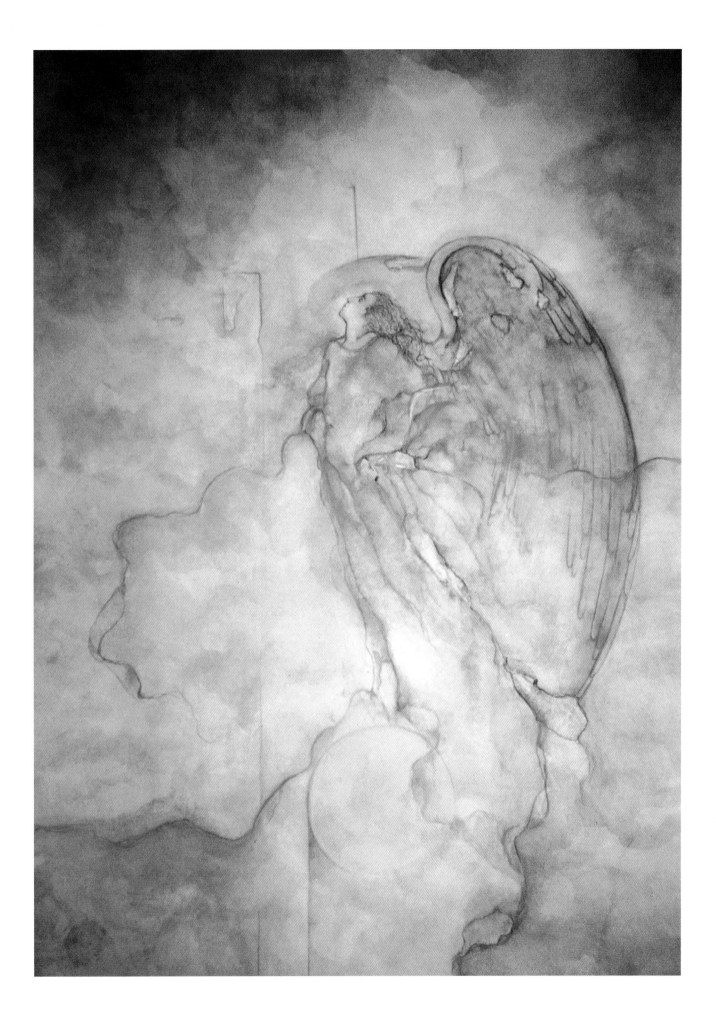

BUTTERFLY

This was a commission for a couple who asked if something could be painted depicting their union that also suggested butterflies. As usual, the vision came to me without hesitation. It signifies *two* butterflies facing each other; yet, when you look at the painting, your first impression is of just *one*. The circle over their heads suggests infinity, a union that is never-ending.

30 x 30 Private Collection

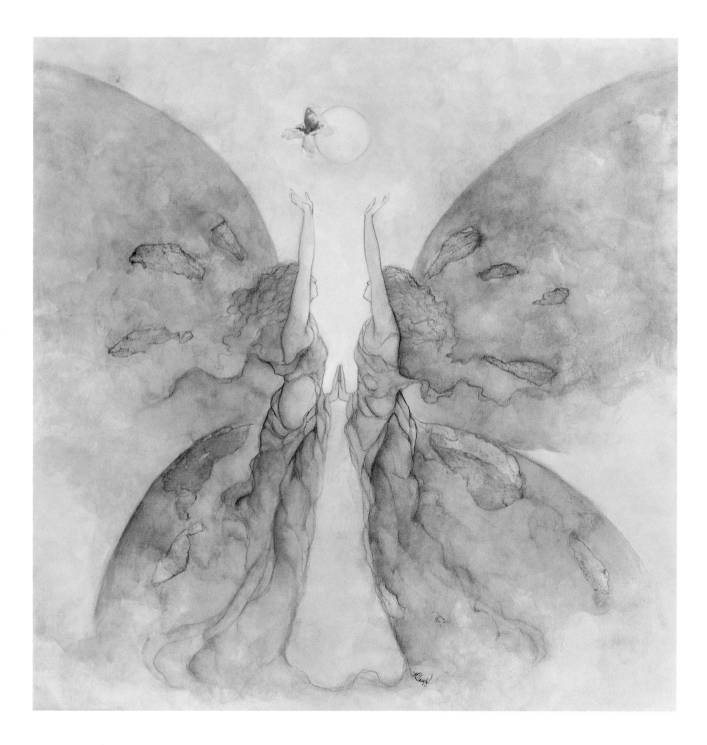

FASCINATION OF THE FAIRY CHILDREN

✿ ✿ ✿

NOCTURNE, THE ASSOCIATION OF MAN AND SPIRIT

✿ ✿ ✿

MOTHER AND CHILD MERMAIDS

I HAVE SUCH FOND MEMORIES OF THE TIME WHEN THESE THREE LITTLE PAINTINGS WERE BROUGHT TO LIFE. I WAS PREPARING FOR A SMALL SHOW IN DEL MAR, CALIFORNIA, AND WANTED TO DO SOMETHING ON A SMALLER SCALE (WHICH PEOPLE HAD BEEN ASKING FOR) IN CONJUNCTION WITH MY LARGER PIECES. THESE WORKS WERE THE RESULT.

EACH PIECE: 8 X 8 PRIVATE COLLECTION

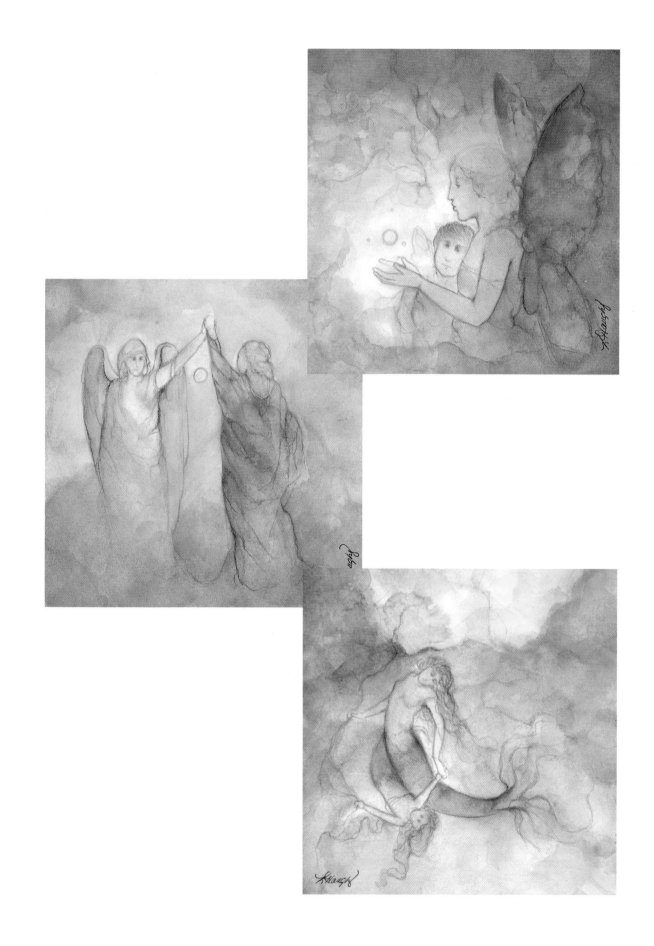

THE ANGEL
OF PROPHESY

This painting is probably one of my more controversial works, due to the coloration, technique, and subject. When I envisioned the piece, I felt an angel, with people woven within her robes and pieces of the tarot inset to form a collage composition. I felt a sense of people longing to know what lies ahead of them on their personal path and the struggle that lends itself to the same concept.

Throughout all my teachings, it has been pounded into my head to first live for the here and now. Reverend Ken Keyes states: "I have everything I need for my here and now."

Louise Hay says: "Everything is in right and divine order in the process of life." But I sincerely feel that people are still in a state of longing and desire to have and know what is on the other side of that door called tomorrow.

20 x 30 Private Collection

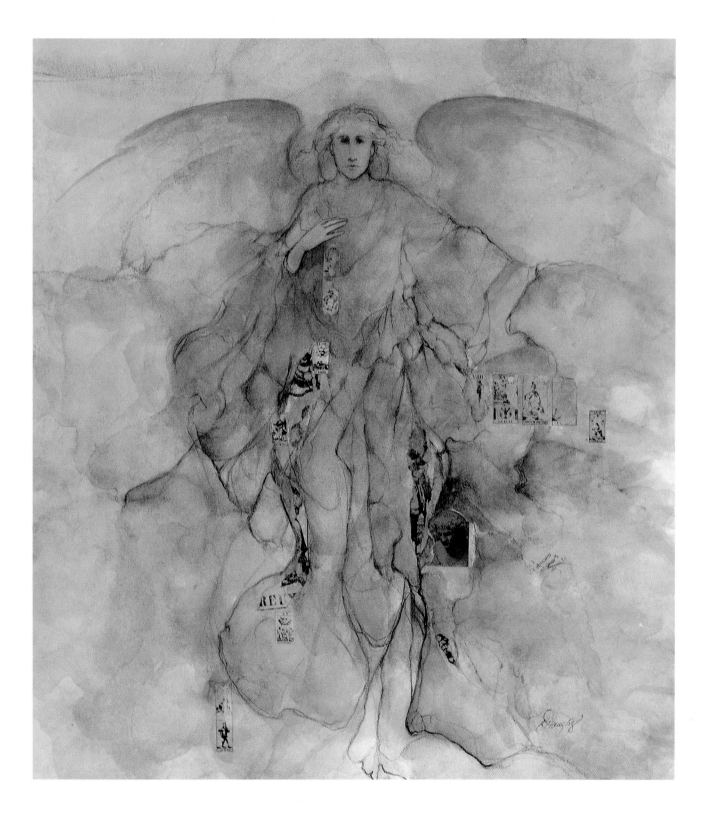

ANGEL FOR
ANN EASTLAND
(HEALING ANGEL)

THIS VERY SPECIAL ANGEL WAS PAINTED
FOR A CLIENT WHO WAS OPENING HER
HANDS-ON HEALING CENTER AND
WANTED AN ANGEL FOR HER OFFICE
WALL. SHE ASKED THAT I QUOTE HER
AS FOLLOWS: "AS A PHYSICAL AND MAS-
SAGE THERAPIST, KAREN'S HEALING
ANGEL IS A FOCAL POINT FOR ME DUR-
ING MY SESSIONS FOR INSPIRATION AND
HEALING. I DRAW ENERGY FROM THE
LOVE THAT KAREN PUTS INTO HER ART."

I THANK YOU, ANN, FOR YOUR KIND
WORDS AND THOUGHTS. PEACE BE
WITH YOU ALWAYS.

20 x 30 PRIVATE COLLECTION

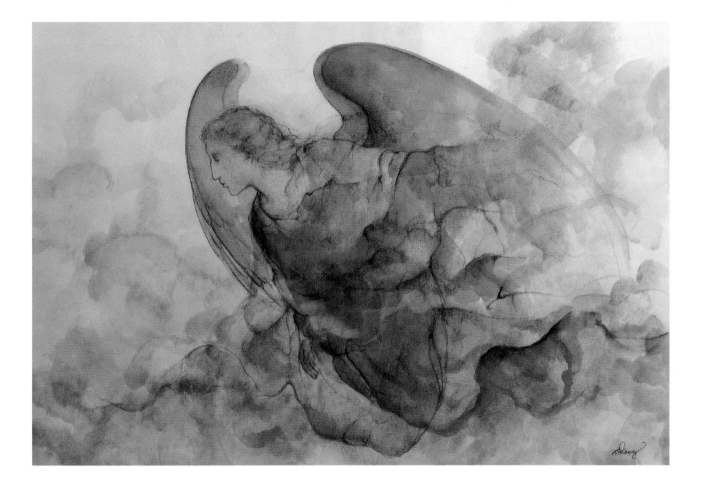

MIST

When I painted *Mist*, my hand literally followed the guides of my brush and unconscious thought patterns. There was no theme or reason for this particular subject matter other than my otherworldly creativity.

I did, however, find it interesting that the three roses came up over the head of the spirit in the painting, because the following day, I made a visit to my mother's home in Fremont, California, and I saw three roses pasted on a mirror over her bed.

She insisted that I was reading her mind again.

20 x 30 Private Collection

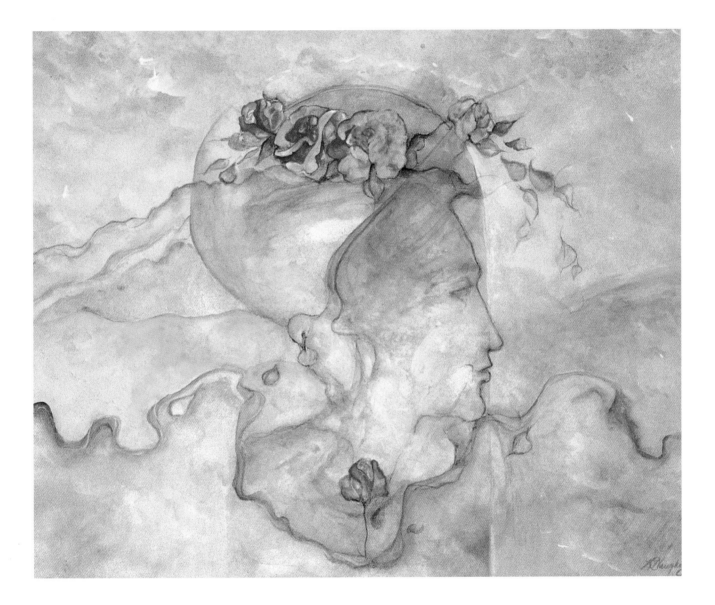

ANGEL
DE LAS FLORES

THIS ANGEL WAS SPECIFICALLY PAINTED FOR THE ANGEL GALLERY IN LOS GATOS, CALIFORNIA. I WOULD VERY MUCH LIKE TO ACKNOWLEDGE THE OWNER, SALLY EDWARDS, FOR HER SUPPORT AND LOVE OF MY WORK OVER THE YEARS. WHEN I PAINTED THIS PIECE, IT CAME FROM A SPACE OF GREAT RESPECT AND MUTUAL LOVE FOR SALLY AND HER WORK.

IF YOU ARE EVER IN THE AREA, PLEASE COME IN AND SAY HELLO, AS I ALSO DO SPIRITUAL AND INTUITIVE COUNSEL THERE ON SUNDAYS. THE SHOP ITSELF IS WORTH SEEING BECAUSE IT IS ENTIRELY DEDICATED TO ANGELS.

THE ANGEL GALLERY, WHICH OPENED IN 1987, WAS ONE OF THE FIRST GALLERIES OF ITS KIND.

30 x 30 PRIVATE COLLECTION

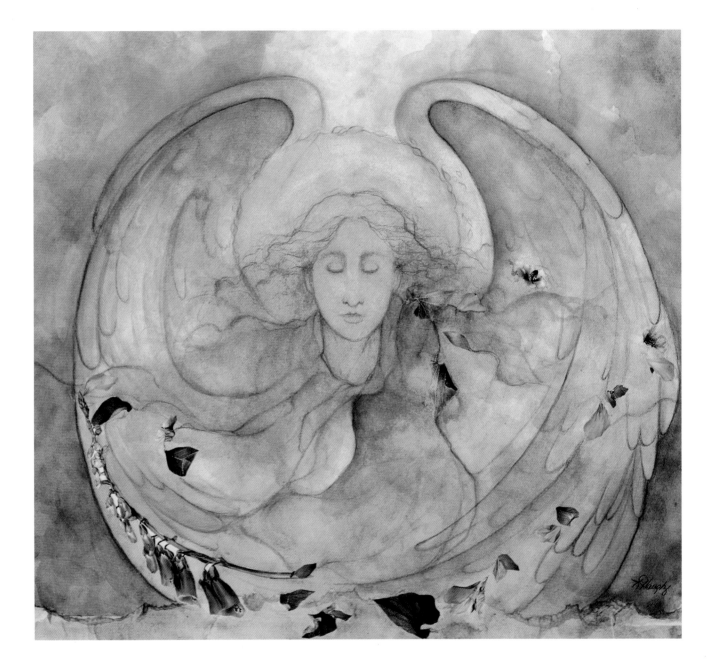

WINGED
FRIENDS I

To me, *Winged Friends I* is an affectionate view of mystical things with wings. Fairies, butterflies, and angels are all relating to each other beautifully. If only we humans could possess this same quality.

18 x 24 Tesori Gallery, San Mateo, California

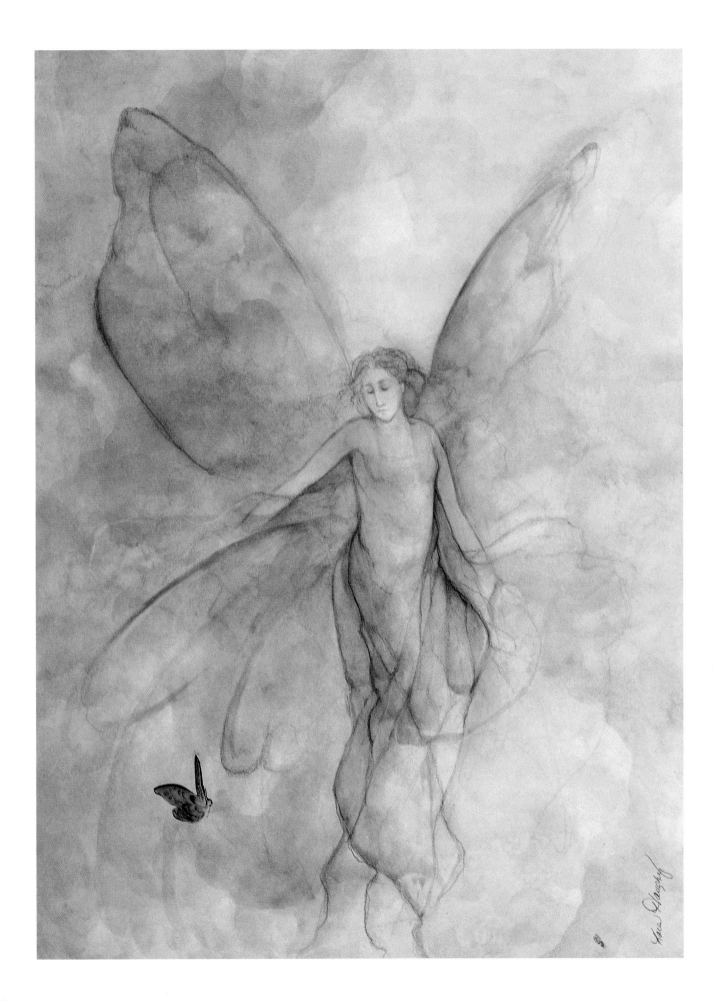

MOON FAIRY

THE MOON FAIRY IS A NOCTURNAL
BEING OF LIGHT, BEAUTY, AND LOVE. I
CAN REMEMBER THE DAYS, HOURS,
WEEKS, AND MONTHS THAT WERE
DEVOTED TO THIS INTRICATE PAINTING
OF WATERCOLORS, PASTELS, AND EXTEN-
SIVE LAYERS OF COLLAGE.

24 X 34 PRIVATE COLLECTION

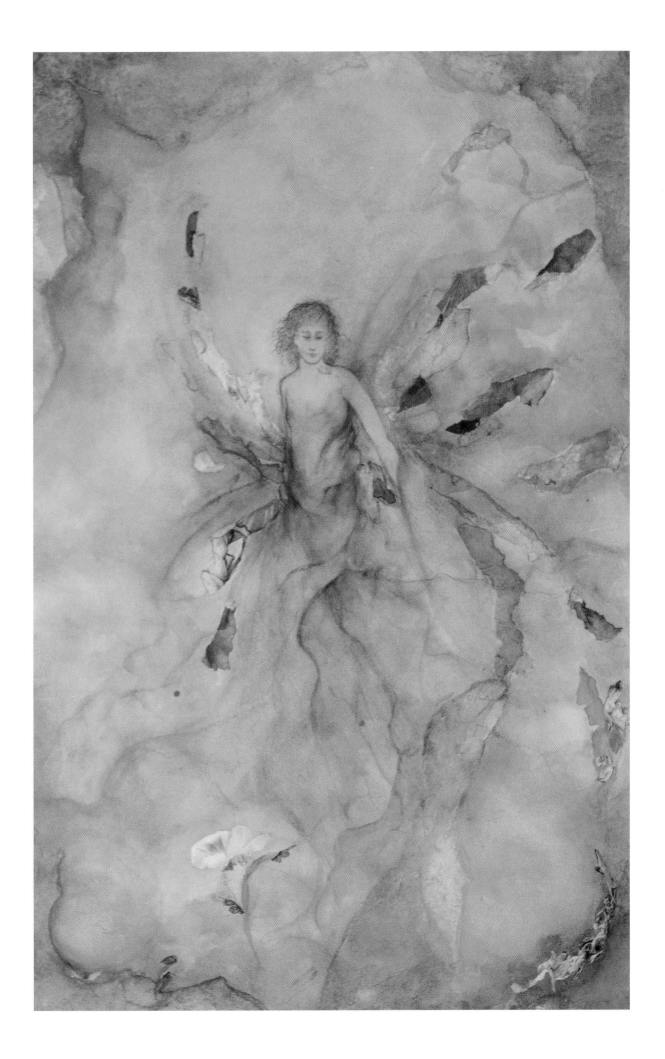

THREE MUSES
OF FATE

This was the saddest and most profound of my angelic commissions. In the fall of 1993, I painted this angelic vision for my friend, Penny Martens, who is also an ordained minister.

On the day I delivered this painting to her, she had a premonition of death. Shortly afterward, her son, Steven, committed suicide. She wrote me, and I quote: "Dear One, you don't only paint our angels, you paint us messages from our angels."

32 x 42 Private Collection

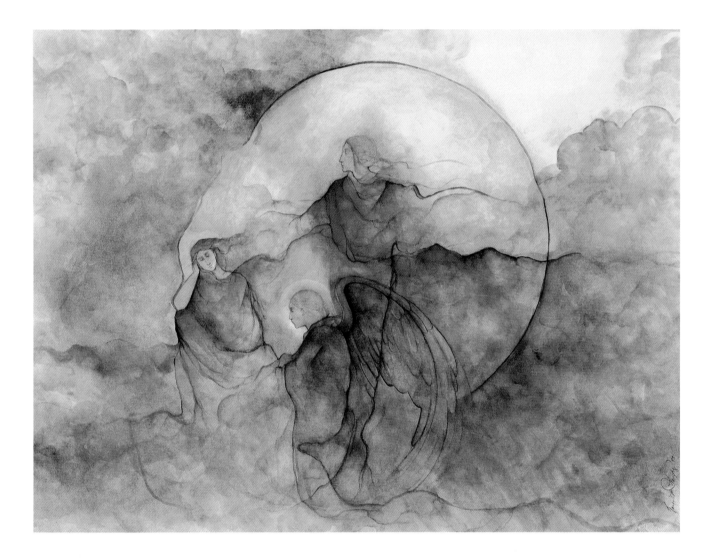

JUDITH ENGLES, GODDESS

This painting was created for Judith Engles, a hypnotherapist in the San Francisco Bay area who was connected with the translation of Greek mythology and the history of Goddess literature. Her own energy manifested this painting; I merely translated it.

20 x 30 Private Collection

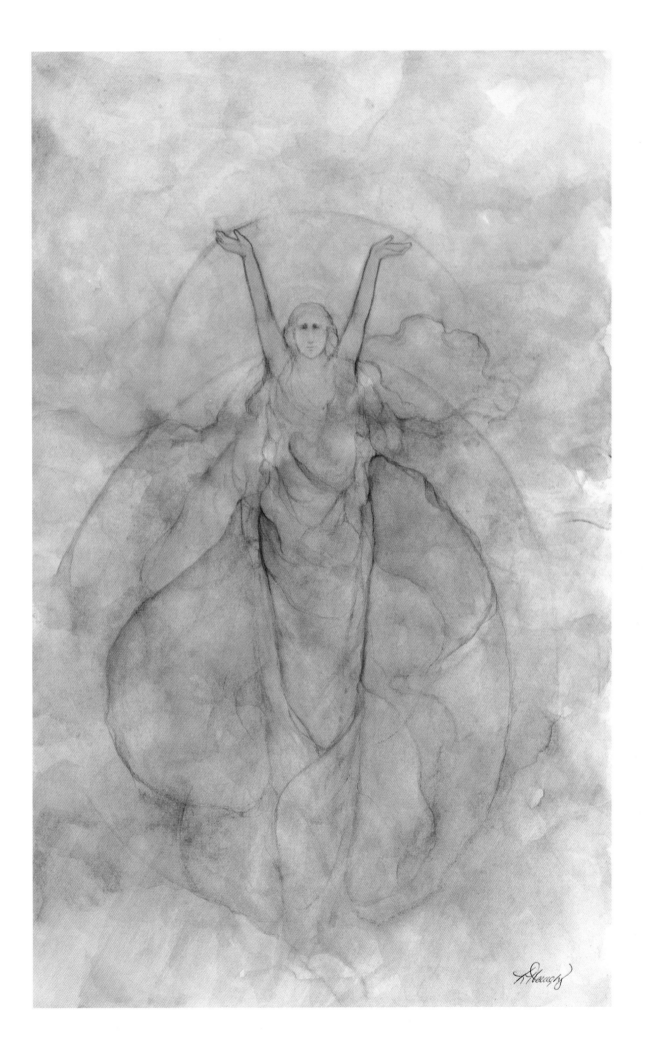

GLORIA WILCOX, GODDESS

This piece represents my compassion for Gloria Wilcox, a woman of great healing power who gives of herself in order to help others, on all levels.

Lavender is a key color for her, and she asked that I paint this essence in those hues. I thought of Saint Germaine and the healing light of the Violet Flame in conjunction with Gloria's own energy.

18 x 24 Private Collection

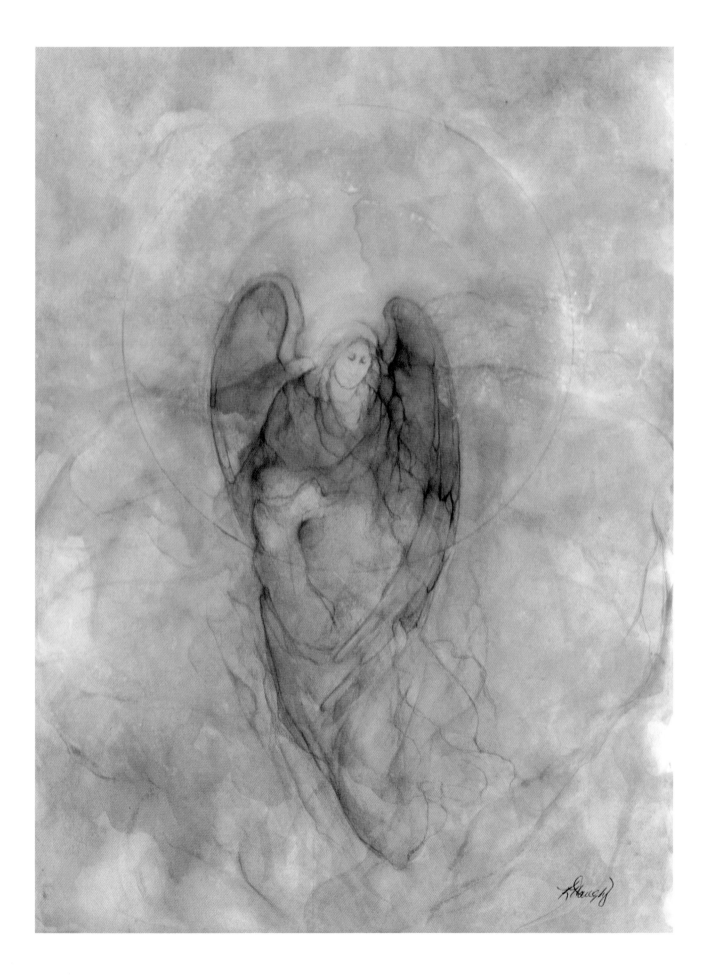

TWO ANGELS FOR KAREN

This painting was actually painted *by* me, *for* me! Believe it or not, it was a subconscious endeavor, because I didn't really get a clear message until halfway through the painting that this one was for me.

There was tremendous transition happening in my life when this painting evolved, along with the birth of this book that you are looking at.

My life turned inside out, and nothing that I've done has been the same since, either physically or emotionally.

There has been much work, little or no play, and many sleepless nights. I have been a very tired lady, but my spirit is full of life and energy with respect to my life's purpose and what I can do for others.

18 x 24 Angel Gallery, Portland, Oregon

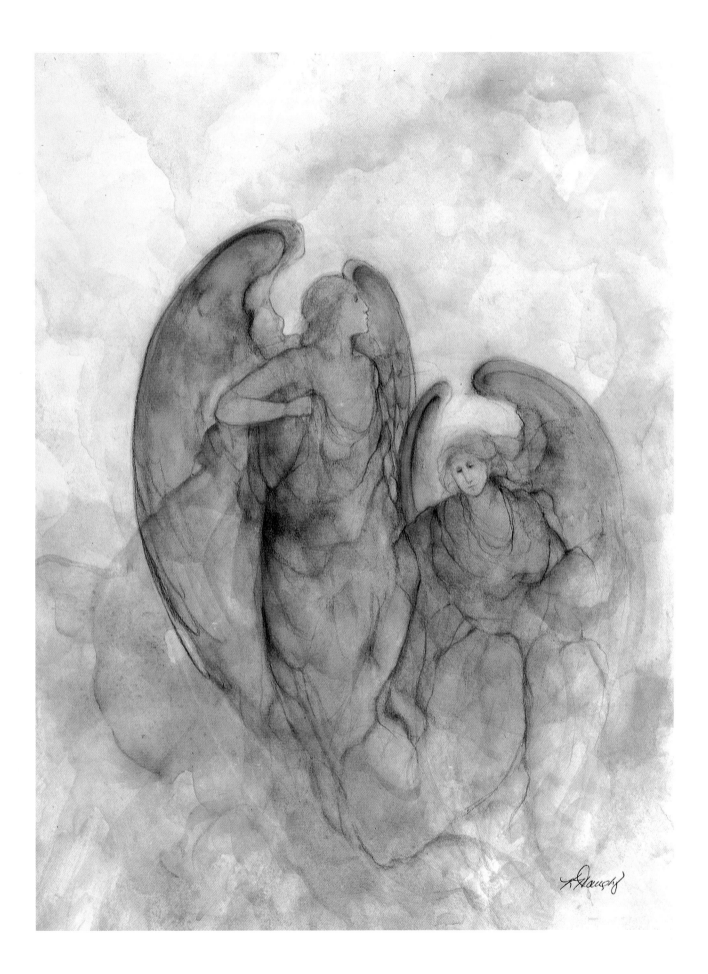

ANGEL OF HOPE

ANGEL OF FAITH

Even though these are two separate paintings, they were initially created on the same board. Halfway through the creative process, I was told by Spirit to separate them, so I cut the illustration board in half horizontally, and they became two instead of one at that point.

They have continually hung side by side in galleries; yet, they have sold as separate units. So my beliefs of hope and faith are actually one and the same, but they are channeled into different categories. One may not live without the other. Where there is hope, there must also be faith. Just believe, and the other two will follow. Release and let go; let God know that you are really not in control. Everything manifests for your higher good.

Each piece: 18 x 40 Angel Gallery, Portland, Oregon

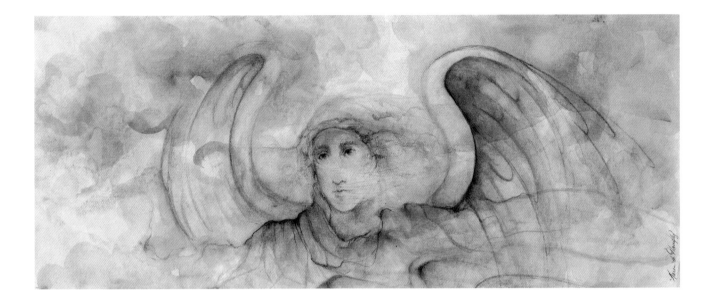

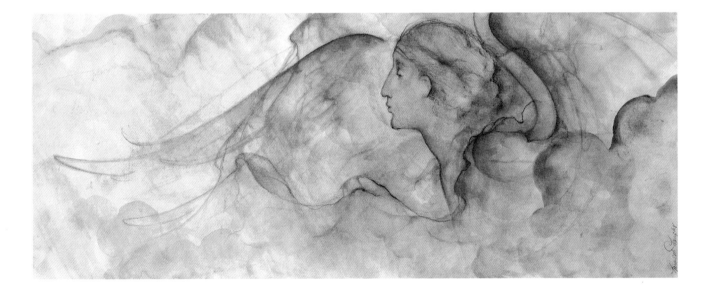

MOSAIC

MOSAIC WAS CREATED FOR AN INCRED-
IBLE PIANIST AND FRIEND BY THE NAME
OF TOM BARABAS IN RELATION TO A
MUSICAL RELEASE MADE AROUND THE
SAME TIME FRAME. WE ACTUALLY MET
THROUGH HIS MUSIC, AS I *SAW* HIS
HEART AND SOUL THROUGH THAT
MEDIUM.

HIS MUSIC TOUCHED MY SOUL AND
SPARKED THIS CREATIVE MESSAGE WITH-
IN MY OWN WORK AS AN ARTIST.

8 X 8 PRIVATE COLLECTION

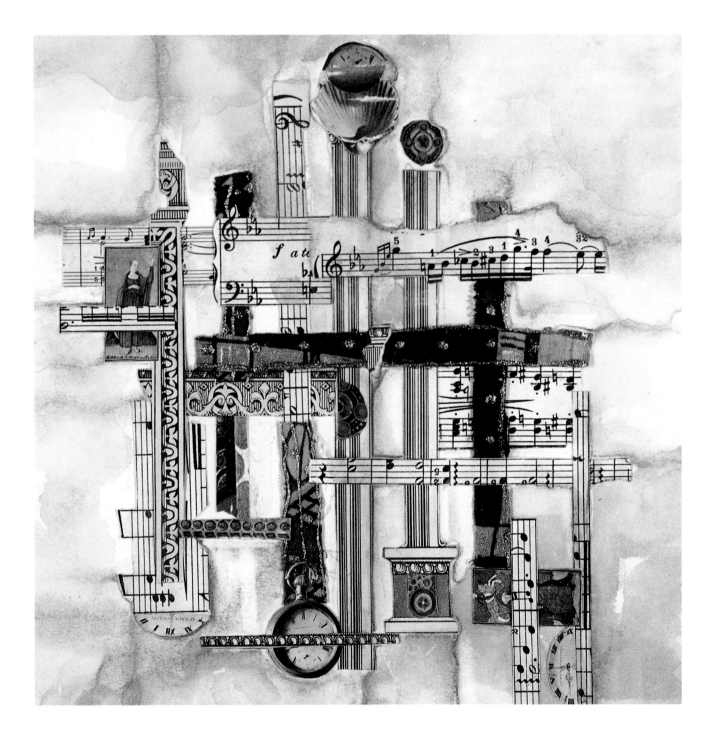

ZANNAH'S ANGEL

I created this angel as a gift to
Zannah in honor of her mission
with "Arc." She wrote the follow-
ing to me:

"You are flawless in the eyes of
love, Exquisite to behold
with ailerons of liberation,
a brilliance to unfold
Each tier of pastel wonder drifts
into its sibling layer
Mankind's own complexion
a universal prayer
He sings to all that listens,
Her dance is for the blind
Its flight will leave you
breathless, Living inside
the spirit's mind
The angel comes in slumber,
a passenger in your car
leaving words upon the
parchment marked with
postage from afar
Hear the purr among the
laughter, Touch the rose with-
out the thorn
Embrace this rainbow of heaven
while another miracle is born...."

11 x 14 Private Collection

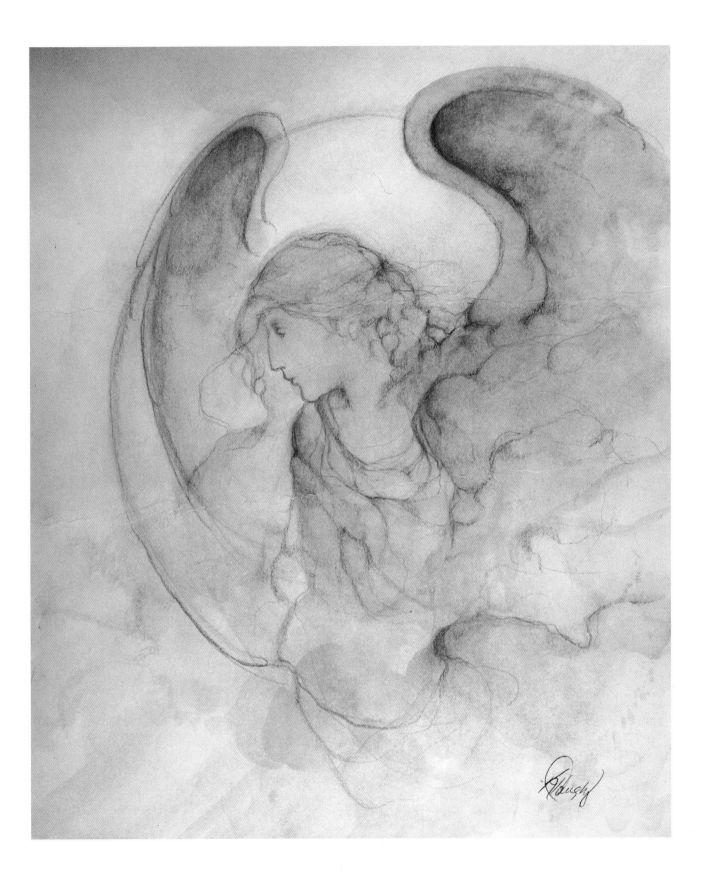

IN MY LONGING

FEELING PARTICULARLY LONELY ONE
EVENING IN EARLY SPRING, 1995, THIS
VISION CAME TO ME, AND I FELT THE
NEED TO PAINT IT. EVEN THOUGH MY
LIFE IS FULL OF BLESSINGS, THERE ARE
TIMES WHEN I FEEL LOST AND ALONE.

20 X 30 ANGEL GALLERY, PORTLAND, OREGON

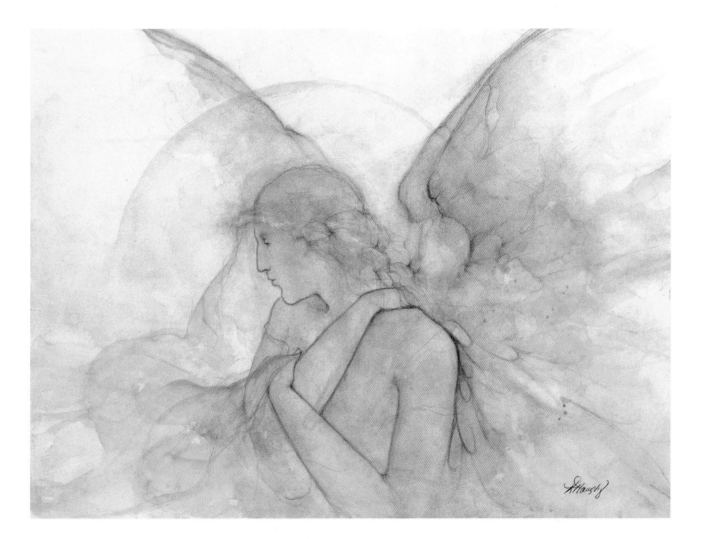

STUDIO ANGEL I

❧ ❧ ❧

STUDIO ANGEL II

THESE ARE CALLED THE STUDIO ANGELS BECAUSE THEY WERE DONE DURING MY CLASSWORK WITH LOUISE HAY. WHEN TIME PERMITTED, I WOULD FLY DOWN TO HER HOME IN SOUTHERN CALIFORNIA AND GIVE HER PAINTING LESSONS.

THESE TWO SHORT STUDIES OF ANGELS WERE CREATED IN TWO SEPARATE LESSONS ON TECHNIQUE, WATERCOLOR, AND PASTEL COMBINATIONS. LOUISE HAS TURNED OUT TO BE A TALENTED ARTIST HERSELF, AND SOMEDAY I HOPE TO SEE A BOOK WITH *HER* PAINTINGS IN IT!

EACH PAINTING: 11 X 14 PRIVATE COLLECTION

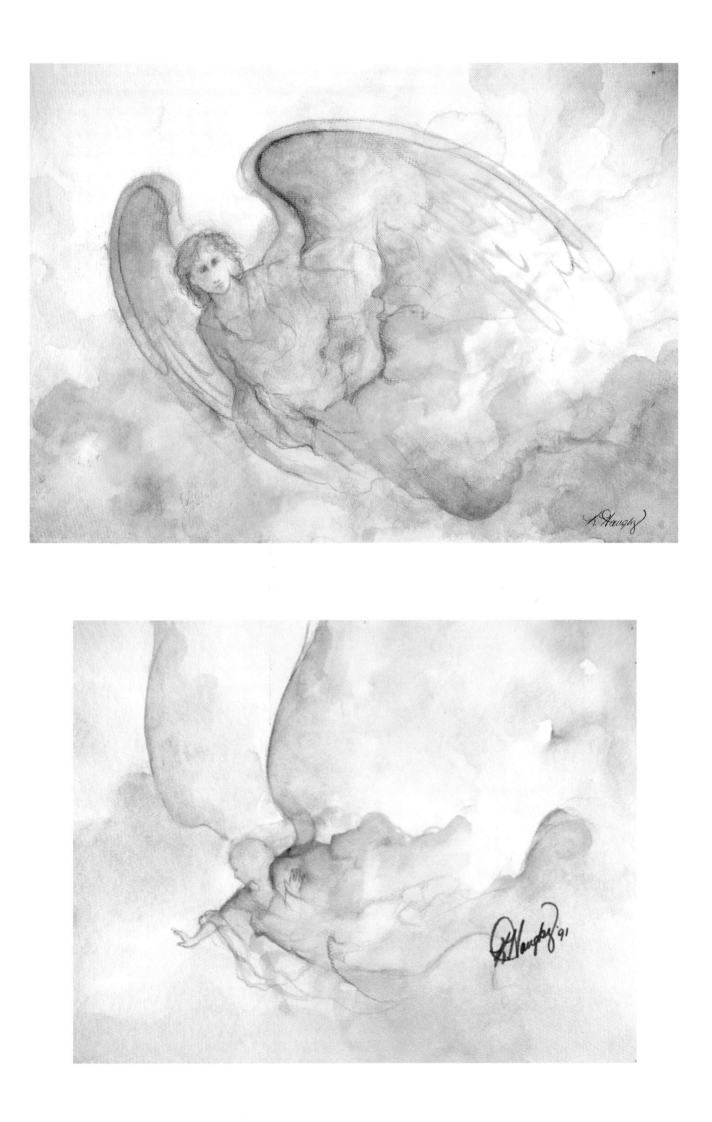

About the Author

KAREN M. HAUGHEY, AN AWARD-WINNING ARTIST, PUBLISHED POET, AND DESIGNER, WAS BORN IN THE SAN FRANCISCO BAY AREA. SHE HAS STUDIED ART SINCE THE AGE OF 10 WITH CHARLOTTE MORTON, A TEACHER AND FINE ARTIST IN CARMEL, CALIFORNIA.

KAREN THEN WENT ON TO STUDY COMMERCIAL ART AND DESIGN WITH THE FAMOUS ARTISTS' SCHOOL IN WESTPORT, CONNECTICUT, AND LATER STUDIED UNDER THE GUIDANCE OF JIM JOHNSON, A FINE ARTIST AND TEACHER AT HARTNELL COLLEGE IN SALINAS, CALIFORNIA. HOWEVER, HER RESULTANT TECHNIQUE, WHICH IS A COMBINATION OF WATERCOLOR, PASTEL, AND COLLAGE, IS SELF-TAUGHT. HER WORK HAS BEEN SHOWN IN PRIVATE AND CORPORATE COLLECTIONS, AND NUMEROUS GALLERIES, THROUGHOUT THE UNITED STATES, EUROPE, AND AUSTRALIA.

SOME OF THE WORKS THAT ARE PRESENTED IN THIS BOOK ARE PART OF THE PRIVATE COLLECTIONS OF INTERNATIONALLY KNOWN AUTHOR AND PUBLISHER, LOUISE L. HAY; AND MR. AND MRS. SAMMY HAGAR OF THE ROCK GROUP, VAN HALEN.

DUE TO THE UNIQUE QUALITY AND DERIVATION OF HER WORK, KAREN'S ANGEL ART HAS BEEN SEEN ON TELEVISION, AND SHE HAS BEEN INTERVIEWED ON NATIONALLY BROADCAST RADIO PROGRAMS AS WELL. IN ADDITION, KAREN'S PAINTINGS HAVE BEEN FEATURED ON SEVERAL BOOK AND MAGAZINE COVERS.

WE HOPE YOU ENJOYED THIS HAY HOUSE BOOK. IF YOU WOULD LIKE TO RECEIVE A FREE CATALOG FEATURING ADDITIONAL HAY HOUSE BOOKS AND PRODUCTS, OR IF YOU WOULD LIKE INFORMATION ABOUT THE HAY FOUNDATION, PLEASE WRITE TO:

HAY HOUSE, INC.
CARLSBAD, CA

OR CALL: **(800) 654-5126**